中国画画世界

The World Through Chinese Painting

南博金基计划

中国画画世界原创艺术活动及科研项目

主办单位
南京博物院

投资机构
江苏金亚房地产开发有限责任公司
南京金基房地产开发集团有限公司

Nanjing Museum - Jinji Plan
"The World Through Chinese Painting" Original Art Activities and Research Project

Organizer
Nanjing Museum

Sponsors
Jiangsu Jinya Real Estate Development Corporation Limited
Nanjing Jinji Real Estate Development Group Corporation Limited

⑦

中国画画世界

The World Through Chinese Painting

意大利 法国 德国卷

Italy & France & Germany Volume

江苏美术出版社

组织者 序

徐湖平

博物馆承担着发掘与弘扬人类文明的重任。一个眼界高远的博物馆管理者，不仅应组织保管利用好已有的历史文物，还应该站在一定高度，去发现与传承现代文化艺术。今天的艺术，经过若干年的时光淘洗，也许就成为明天的文物珍藏，就像凡·高、莫奈、毕加索，乃至国内傅抱石、钱松嵒的作品一样。

江苏历史悠久，文化灿烂，尤其绘画艺术，自古以来就有着得天独厚的发展优势，遥遥领先于全国其他地区。早在东周时期，江苏的绘画艺术已达较高水平。六朝以来，江苏或为京畿要地、或为经济中心，绘画艺术一直保持强势发展，诞生了一系列对中国绘画史产生巨大影响的美术家和绘画流派。新中国成立后，傅抱石、钱松嵒又创立了"新金陵画派"，以新山水、新画风引领潮流，在现代绘画史上书写了浓重一笔。他们的作品，乃至历史上江苏各名家的作品，而今都是博物馆里的珍贵馆藏，是有识、有能之士争相收藏的珍宝，是人类文化的宝贵财富。面对这些，我们不禁要问，进入21世纪，在改革开放、经济快速发展的今天，江苏绘画将给后人留下什么?怎样才能再续辉煌?我辈又能在其中起到怎样的积极作用?

1999年南博艺术馆投入使用后，我们在抓好历史陈列的情况下，充分利用得天独厚的场馆与资源优势，组织现代艺术品的陈列、研讨与出版活动，在扶持现代艺术方面做了大量工作，也在相当程度上扩大了南博的知名度与影响力。在相关研讨中，南博艺术研究所副所长庄天明向我提出了"中国画画世界"的命题与构想，我立即意识到这是一个难得的好选题。我们探讨细节、明确形式，很快形成了完备的方案。这个被称之为"中国画画世界"的艺术活动，得到了民营企业家江小群和卢祖飞的青睐，也得到了江苏有识画家的积极响应。

整个活动计划分10年完成。前8年为创作展示期，后2年为活动成果推广期。由南博策划组织，由江苏金亚房地产有限公司、南京金基房地产开发有限公司联合投资，吸纳江苏最具知名度和创作潜力的画家参加，目前已有十余位画家自愿签约。活动设定每年组织8位左右的画家出国写生一次，回国后全面投入艺术创作，每年举办专题展览、出版画集。计划以8年时间周游包括南北极在内的七大洲，以中国特有的画笔、颜料去挥写全球山河大地、风土人情之集萃。8年采风活动结束后，将精选出优秀作品，出版大型画集，花2年时间到全国各大城市及世界有关国家作巡回展览，向全国和世界热爱艺术的观众，展示当代中国画家表现与创造的才华，以及中国画艺术语言形式开拓与发展的巨大潜能。我们坚信，此举一定会有力地激发中国画的良性生态，促进对于中国画未来发展形态的学术研究，进一步确立中国绘画的优越性的世界地位。

组织策划方、投资方、签约画家，几方共同磋商，积极推动，"中国画画世界"原创艺术活动及科研项目于2005年下半年正式启动。首次签约活动便引起了业界和媒体的广泛关注，《美术报》称其为"举世无双的划时代壮举"。

2006年初，我们开始实施了第一次国外写生计划。由我带队，率8位签约画家奔赴巴西与古巴进行采风创作，用中国画笔挥写着异域风情，一批别具特色的中国画作品应运而生。我希望并且坚信："中国画画世界"活动一定会在江苏绘画史上留下浓重的一笔；投资方投资赞助的这一项目一定是一项成功的艺术品投资举措；签约画家们的精品力作一定会成为当代国画创作新的典范。在展示当代江苏画家乃至中国画家的表现与创作才华的同时，也让大家感受到中国画语言形式开拓发展的巨大潜能。

Preface by the Organizer

Xu Huping

Museums are charged with the important responsibility of promoting human civilization. If the managers of a museum have foresight, they would not only protect and make good use of the existing collection, but also elevate the collection to a new height by actively discovering and showcasing modern culture and art. As decades go by, today's art will perhaps become tomorrow's prized antiques, in the same way that works of Van Gogh, Monet, Picasso, and even China's own Fu Baoshi and Qian Songyan did.

Jiangsu Province has a long history and an impressive cultural heritage. In particular, the province has far outstripped the rest of the country in the quality of its paintings since ancient times. As early as the Eastern Zhou period, painters in Jiangsu had already attained a high level of achievement. Ever since the Six Dynasties, Jiangsu—either as a political capital or a trade center—has been able to maintain a constant and remarkable progress in the development of its art, giving birth to generation after generation of artists and painting schools that had tremendous bearing on the history of Chinese painting. After the founding of New China, Fu Baoshi and Qian Songyan created a "New Jinling School of Painting" that set novel trends with their new landscapes and new style, leaving a distinct mark on the history of modern painting. Their works, as well as the work of fellow Jiangsu masters throughout history, have become priceless treasures in today's museums, in the collections of elite collectors, and in world as a powerful testimony of human ingenuity. Considering the vastness of Jiangsu's past cultural impact, we must ask, in the 21st century, after the reform and opening of China and the ensuing economic boom in the nation today, what new legacy will Jiangsu painters create for future generations? How will Jiangsu sustain its artistic glory? And specifically, how can our own generation contribute to that legacy and glory?

Having already devoted ample attention to our historical displays after Nanjing Museum of Art was put into use in 1999, we now wanted to make even better use of our unique venue and resources by organizing a modern art exhibition, seminar and publication event to promote the importance of modern art while, to a considerable extent, simultaneously expanding the Museum's popularity and sphere of influence. In the ensuing discussions, Nanjing Museum's deputy director of the Institute of Arts, Mr. Zhuang Tianming, described his vision for "Chinese Painting, Painting the World,"and I immediately realized that we had discovered a rare, interesting angle. We talked over the details, clarified the format, and soon formed a complete plan. This event, which we named "Chinese Painting, Painting the World,"received patronage from private entrepreneurs Mr. Jiang Xiaoqun and Mr. Lu Zufei, and garnered positive responses from renowned artists in Jiangsu Province.

The whole project will take 10 years to complete. The first 8 years will be an original art creation and display period, with the last two years aimed at promoting the results of the project. With Nanjing Museum as the organizing institution, sponsored by Jiangsu Jinya Real Estate Development Co., Ltd. and Nanjing Jinji Real Estate Development Group Co., Ltd., our project has attracted a team of the most prestigious painters from Jiangsu's art world. To date, there are already a dozen artists who have voluntarily signed on. Every year, we will make arrangements for around 8 of these artists to travel abroad. Once they return from their trip, they will immerse themselves in a period of artistic creation, followed by participating in the annual exhibitions and publishing their art collections. We plan to take the artists to all seven continents, including the North and South Poles, within 8 years, travelling the entire globe to find inspiration from the unique ethnic landscapes and customs they encounter, creating a thorough collection of their impressions of the world through the visual language of Chinese painting.

After the 8-years-long material collection phase is complete, we will select outstanding works for a large-scale publication. We will hold a 2-year-long travelling exhibition in major cities across the country and in the world, showing art-loving audience—Whether domestic or foreign—the immense promise of today's Chinese painters, and of the Chinese painting art form itself. We have faith that that our project will effectively reinvigorate the current health of Chinese painting. We have faith that it will shed light on academic research topics surrounding the future of Chinese contemporary art, too, further consolidating the superiority of Chinese painting in the world.

Everyone involved—from the event planners to the investors and to the contracted painters—consulted together and actively promoted "Chinese Painting, Painting the World."This original art and scientific research project was officially launched in the latter half of 2005. The opening activities attracted extensive media attention, with "China Art Weekly" going as far as calling it an "nparalleled, epoch-making feat."

In early 2006, we began our first overseas painting expedition. I took eight of the contracted artists with me to Brazil and Cuba, where we captured the exotic culture in Chinese brush painting to create a collection of distinct, flavorful Chinese art. I hope and believe that "Chinese Painting, Painting the World" will definitely be a glorious new chapter in Jiangsu Province's history of painting; the investors definitely will reap abundant rewards from sponsoring this project; and our contracted artists?masterpieces will definitely set a new golden standard for contemporary Chinese painting. From a even broader perspective, while we are showcasing the creative talents of Jiangsu's and China's contemporary artists, we are at the same time, proving to the entire world that the art form of Chinese Painting still holds tremendous potential for development.

策展人语

庄天明

考察中国的人文传统，有很大的胸怀与很高的目标。胸怀之大、目标之高，有"平天下""世界大同""天人合一"等词语自觉与不自觉地影响着一代又一代的中国文化人。无奈由于历史与政治等原因，中国在近代进入了低谷，八国瓜分之羞，日本入侵之耻，是中国堕落至最低潮的标志。正所谓有升必有降，有衰必有盛，改革开放使中国摆脱了贫穷与落后，逐渐富裕与强大起来；也使中国人充满自信地投入到中华复兴的伟大事业中去。改革开放给中国带来了蓬勃生机，给中国文艺界带来了真正的"百花齐放"，也使"中国画画世界"成为可能，成为当代画家挑战自我、挑战时代、挑战历史与古人的一大举措。

考察近现代中国画家表现外国风情的艺术创作（亦可称之为"中国画画世界"），拟可分为三个阶段：一为民国时期的初步尝试阶段；二为解放后至"文革"前的初见成效阶段；三为改革开放以后的普及提高阶段。

第一阶段为民国时期的初步尝试阶段。有据可查的用中国画形式表现外国风景人物的画家有何香凝、刘海粟、高剑父、徐悲鸿等。何香凝与刘海粟于1930年在法国合作《瑞士勃朗峰》，虽异国风味不浓，然开了近现代中国画画世界的先声。其次，高剑父1932年始创作了一批印度、缅甸题材的山水与人物画；徐悲鸿则于1940年间创作了《泰戈尔像》与《印度妇人像》等人物画。高剑父与徐悲鸿都能结合自己的风格，构出所画对象的形貌特色，是中国画画世界一个良好开端。

起始于解放后至"文革"前的第二阶段，有机会参与画世界的画家人数渐多，作品数量渐增。其中石鲁1955年画印度、1956年画埃及的风景与人物；1957年，傅抱石画罗马尼亚、捷克斯洛伐克风景，李可染画德国风景；另有张大千1960年以后画日本、瑞士等国山水，叶浅予画外国舞蹈等等。上列画家表现外国题材的作品都比较成功，加上及时出版与发表，影响较大。所以，可以将这一时期称之为初见成效阶段。

改革开放以后可称之为第三阶段，即普及提高阶段。画家们借助祖国开放之利、经济上升之便，出国考察采风与创作作品者越来越多，但被艺术界公认的作家与作品且有限。所以普及是事实，提高是这一代画家所面临的攻关项目。怎样表现外国风情，怎样处理好传统与创新的关系，怎样凸现个人语言风格与时代精神风貌，怎样超越前人画世界的成就……这些都是大家所关心与面临的重要课题。

徐湖平院长任内嘱我设想一个重要的、具有可操作性的艺术创作选题，利用南博的品牌资源、江苏美术力量雄厚的优势、对文化艺术有兴趣的投资机构，合作做一件有意义的事情。我以往在出国工作考察期间，常为异国风光与情调所激动，同时积累了不少外国风情的资料与素材，心中做着"画遍全世界"的梦。所以，当徐院长提到重要选题之时，我便提出了"中国画画世界"的大题目。徐院长当即首肯，并要我尽快形成可操作的策划书。于是"中国画画世界"便由理想化作计划。

"中国画画世界"的投资代表江小群先生是我认识多年的朋友，当我与他谈到这个题目时，他说："有意思，这个项目就由我来投资了。"徐院长与江总也是一见如故，当即敲定了合作的关系。真没想到这么快就找到了合作伙伴。接着便联络年龄在45～50岁之间的江苏中年实力派知名画家自愿签约参加该活动，也得到了大多数预选画家的支持，加盟这一原创的艺术活动与科研项目。

按照本人的预想与愿望，我希望通过这个活动来创造江苏乃至全国美术史上的一个新的篇章。这个画家群体最终将成为"世界画派"，他们创作的作品与完成的业绩能够继续江苏历代美术的辉煌。这虽是一个宏伟的计划，但要完成预想的目标，大家面临着巨大的挑战，也必须有丰硕的成果来作总结。所以从"宏伟的计划"至"巨大的挑战"至"丰硕的成果"之间，有很长的路要走，有很多的工作要做，更有很多困难需要克服与解决。

"宏伟的计划"已经确定，下面面临的是"巨大的挑战"。就拿画家们进行采风与创作来论，画家面临着挑战自我，挑战前人与古人，以及挑战同伴，同时挑战时代与创新等等，这是一个需要勇气、智慧与非凡精力的巨大劳动！

江苏无愧"美术巨省"的称号，考之中国与世界美术史，绘画历史这么长、这么强，渊源深厚、香火不断的地区，非江苏莫属。所以我将江苏称之为全中国与全世界范围的美术巨省。这个时代的画家能否继续以往辉煌的业绩，这批画家能否作出江苏先辈画家一样重大的贡献？作为这个活动的策划人与参与者，我衷心地期盼与热切地渴望着！

A word from the Curator

Zhuang Tianming

The study of China's cultural tradition is an expansive and lofty goal. The expansiveness and the loftiness of this goal stems from the conscious and subconscious influences that phrases like "World Peace," "One World," "Harmony between Heaven and Man?had on generation after generation of Chinese intellectuals. Due to historical and political reasons, China hit its all-time low during the invasions by the Eight Power Allied Forces and by the Japanese. But, as the saying goes, what goes up must come down, yet the loser will someday become the winner. So it is that after the reform and opening, China has risen out of poverty and backwardness, growing wealthier and more powerful year by year; the people, too, have poured their confidence and devotion into rebuilding the nation. The reform and opening has brought a new vigor to China, truly letting "a hundred flowers bloom" for Chinese art, making it possible for a monumental event such as "Chinese Painting, Painting the World"—where contemporary artists can challenge themselves, the times, and China's ancient past—o take place.

We can divide the story of Chinese painters painting foreign cultures (also known as "Chinese Painting, Painting the World") into three stages: 1) the initial, trial stage during the period of the Republic of China; 2) the early progress from the period between the founding of the People's Republic to before the Cultural Revolution; and 3) the popularization and improvement stage after China's reform and opening to the outside world.

The first stage, or the trial stage, saw well-documented artists who used the aesthetics and techniques of Chinese painting to reinterpret foreign scenes, including He Xiangning, Liu Haisu, Gao Jianfu, and Xu Beihong. He Xiangning and Liu Haisu's 1930 collaboration in France, Mont-blanc, Switzerland, was the first step towards using Chinese painting to paint the world, although the work did not possess much exotic flavor. Shortly after, Gao Jianfu depicted India and Burma through a number of landscapes and portraitures starting in 1932; Xu Beihong, circa 1940, painted Tagore and The Indian Woman among other portraits. Gao Jianfu and Xu Beihong were able use their own artistic styles to articulate the characteristics of their subjects, putting the project of Chinese painting, painting the world at an excellent starting point.

The second stage lasted from the formation of the PRC until the Cultural Revolution began. It gave more artists the opportunity to paint the world. Shi Lu painted the sights and peoples of India in 1955 and Egypt in 1956; in 1957, Fu Baoshi painted landscapes of Romania and Czechoslovakia while Li Keran painted Germany; Zhang Daqian painted Japan, Switzerland, etc. after 1960. Ye Qianyu recreated images of foreign dances and so on. These artists achieved renown through their exotic subjects, and the timely publication and distribution of their works helped them to make a large impact. Therefore, this period can be thought of as the stage of initial success.

After the reform and opening, we have seen a third stage marked by universal progress. More and more artists, benefitting from our nation's opening foreign policy and booming economy, went abroad to study different cultures and to create original works. Nevertheless, only a handful of them have gained international recognition. So, the goal of this generation of study-abroad painters is no longer increasing the quantity of works, but rather the quality. How to express foreign customs, how to balance tradition and innovation, how to highlight one's own style and capture the spirit of the times, how to surpass painters of the two previous stages ... these are the major dilemmas that all of us now face.

Mr. Xu Huping, during his term as President, asked me to envision a relevant and practicable creative project that would combine the resources of the Nanjing Museum, the strength of Jiangsu's art circle, and the interest of the province's investment institutions to produce something meaningful. My personal experiences abroad were filled with excitement and inspiration, which is why I have been amassing research on foreign cultures and dreaming of a day when I will have painted all over the world. This is also why the idea of "Chinese painting, Painting the World" leaped into my head as soon as President Xu made his request. He approved on the spot and asked me to start planning as soon as possible. From that moment on, "Chinese Painting, Painting the World" was rapidly put into motion.

The representative from the investment institutions for "Chinese Painting, Painting the World" Mr. Jiang Xiaoqun, is my friend of many years. When I approached him, he said: "Interesting, I'm going to invest." Mr. Jiang hit it off right away with President Xu, too, and with unexpected speed, our project had an official sponsor. Then, we looked for middle-aged (between 45-50) elites among the well-known painters in Jiangsu who would be willing to participate in original painting and research project, receiving support from the majority of our intended candidates.

I hope that this event will open a new chapter in the history of Jiangsu Province's art, or even Chinese art at large. According to my expectations and wishes, this group of artists will eventually become a "global school of painting," creating masterpieces that continue Jiangsu's long tradition of dominating the Chinese art scene. This is an ambitious goal. Before we can realize it, we will have to battle great challenges and emerge from them with fruitful victories. Therefore, from the "ambitious goal" to the "great challenges" to the "fruitful victories,"there is a long way to go, a lot of work to do, and a lot of difficulties to overcome and resolve.

So far, the "ambitious goal" has been identified. What comes next are the "great challenges." In the act of drawing from foreign inspirations, artists will be challenging themselves, challenging their recent and ancient predecessors, challenging their peers, challenging concepts of modernity and innovation… all this, and much, much more. This is a grand mission that will require courage, wisdom and extraordinary energy!

Jiangsu Province is undeniably the "Art Giant" of China. Indeed, in the country or around the world, there is no other place that can boast of a history of painting that is as long, as strong, as packed, or as uninterrupted as Jiangsu Province. This fact alone makes Jiangsu's art a force to be reckoned with both on a national and international level. Will today's painters carry on the glory of the province? Can these artists contribute to Chinese art at the same level as past Jiangsu artists? As this event's curator and one of its participants, I sincerely hope and eagerly yearn for our "fruitful victories"!

投资机构代表语

江小群

2005年，由南京博物院前院长徐湖平先生发起与主持，南京博物院艺术研究所所长庄天明先生精心策划，南京博物院主办，江苏金亚房地产开发有限责任公司与南京金基房地产开发集团有限公司联合投资协办的"南博金基计划——'中国画·画世界'原创艺术活动及科研项目"正式启动，至今已成功地按原计划连续进行了四年的活动，取得了有目共睹的丰硕成果。

回想四年之前，当该活动策划人庄天明告知我南京博物院正在筹备"中国画·画世界"这么一个长达十年时间的原创艺术活动项目，欲寻找投资机构合作支持时，我首先被这个计划宏伟的创想所打动。当我看了项目策划书以后，我当即承诺投资这个充满激情与挑战的原创项目。同时我考虑到这个项目规模比较大，时间比较长，就和我多年好朋友南京金基房地产开发集团有限公司董事长卢祖飞先生商量由我们两家公司（江苏金亚房地产开发有限责任公司和南京金基房地产开发集团有限公司）联合投资，这就是该活动所以称之为"南博金基计划"的缘由。资助这样有潜力的大型文化项目，其意义是多方面的：首先，按照该活动策划之目标，这应该是一项很有价值与意义的艺术活动，并将成为一个著名的品牌活动；其次，资助这种品牌活动，可以起到宣传企业形象的效果；同时，还能收藏到一批当代优秀画家的原创性的艺术作品，为企业积累不同凡响的精神与物质财富。于是我们毅然与南博与签约画家们携手合作，投身于这个被《美术报》称之为"举世无双的划时代壮举"的项目。

随着这个项目的起动，我们很快就发现，这个活动不但意义重大，而且乐趣无穷。参与这项活动的签约画家们在激动于异国文化风情、惊叹千姿百态的艺术样式所具有的特殊表现力的同时，更加关心的是中国国画的现代性、民族性与世界性的问题，关心的是中国画的艺术观念和表现方法如何创新与发展，如何更加符合国际艺术的趋势，如何更加具有国际地位等问题。话头每每打开，总能感觉到他们对当今中国画发展前景的忧患意识与责任感与使命感。同这些可敬可爱的画家们深入交流，我们受益匪浅；他们让我们清楚地认识到：这项投资本身极富意义。

在"中国画·画世界"这个简明醒目的标题里，"中国画"绝不仅仅是一种绘画技法标识的画种，更是一种文化艺术的观念；"画世界"也绝不仅仅提示着题材的扩大与转换，更重要的是当代中国画家的心灵对世界各种文化现象的透视与碰撞。当代中国画当秉承一种什么样的艺术观念，是个重大的问题，需要从理论、更需要从实践上作出创造性的回答。当代中国画家对敞开了的现代世界作怎样的透视与解读，创造出怎样的、越来越富新意与经典性质的中国画新作品，则需要画家们作出不断的努力，尤其需要的是画家们通过心灵的修为达到那更高的艺术境界。我们希望画家们通过这个非同寻常的艺术活动，创作出更加自由的、大胆的、更富有新意与感染力的作品。同时我们坚信，这个投资项目是一个明智与有价值的选择，也是我个人一生中所做的最有价值与意义的事情。

我们与南京博物院、与签约（特邀）画家们的合作非常的愉快；我们期盼着这份愉快的巩固与发展！

A word from the Sponsor

Jiang Xiaoqun

In 2005, initiated and chaired by Mr. Xu Huping, former president of the Nanjing Museum, with the meticulous planning of Mr. Zhuang Tianming, Dean of the Art Research Institute under Nanjing Museum, Nanjing Museum organized the "Nanjing Museum & Jinji (Nanbo-Jinji) Plan—'Chinese Painting, Painting the World' Original Art and Research Project," which was jointly sponsored by the Jiangsu Jinya Real Estate Development Co., Ltd. and Nanjing Jinji Real Estate Development Group Co., Ltd. Since then, the project has been running according to plan for four continuous years, achieving palpable success and yielding fruitful results.

Thinking back to four years ago when Mr. Zhuang told me that Nanjing Museum was preparing a decade-length original art project and looking for an investment partner, I recall being immediately moved by the grand imaginativeness of "Chinese Painting, Painting the World." I committed to the investment as soon as I finished reading the project proposal, infected by the same passionate and defiant spirit that permeated from its pages. At the same time, taking into consideration the substantial size and duration of the project, I went to my friend of many years and the Chairman of Nanjing Jinji Real Estate Development Group Co., Ltd., Mr. Lu Zufei, to discuss the possibility of a joint sponsorship by our two companies (Jiangsu Jinya Real Estate Development Co., Ltd. and Nanjing Jinji Real Estate Development Group Co., Ltd.)— hence, this project became known as the "Nanbo-Jinji Plan." Our purpose for investing in a large-scale cultural project with so much potential was multifaceted: First, in accordance with its proposed objectives, this should be a momentous event that would evolve into a well-known brand name; Secondly, in sponsoring such a brand, we can promote our corporate image; Lastly, we could also collect a number of original works by outstanding contemporary artists, accumulating spiritual and material wealth for our enterprises. Therefore, we had no hesitation in signing with Nanjing Museum and the contracted artists to collaborate on this project, which has been heralded by "China Art Weekly" as an "unparalleled, epoch-making feat."

As the project began to take shape, we quickly realized that what we were doing was not only vital, but also incredibly exciting. While the artists who participated in the project were inspired by foreign cultures and marveled at the unique expressivity of a myriad of artistic styles, they focused more on issues of modernity, ethnicity, and universal accessibility in Chinese National Painting. In particular, they were concern with topics such as how to innovate and develop the way Chinese painting is conceptualized and carried out, how to update it to suit international trends, and how to further elevate its status in the global arena. During each discussion on the prospects of contemporary Chinese painting, we would be awed by the sense of urgency, the sense of responsibility, and the sense of mission that radiated from each participant. These profound, constructive exchanges with such venerated artists have illuminated our own mission: we realize the undeniable significance of this investment.

In the pithy title of "Chinese Painting·Painting the World," "Chinese Painting" does not only pertain to a certain type of painting technique or visual idiom, but also to a cultural and artistic point of view. Likewise, "Painting the World" does not only describe the broadening and shifting scope of subjects in the artworks, but more importantly examines contemporary Chinese artists as their souls perceive and collide with various worldwide cultural phenomena. What kind of perspective should contemporary Chinese painting adopt? This is a major question that requires a theoretical and, moreover, a practical approach in order to obtain a creative response. How do contemporary Chinese artists read and respond to a world that has become progressively more open? How can they create modern classics that are simultaneously more innovative? These are obstacles to Chinese painting that will require tenacious efforts on the part of contemporary painters—specifically, contemporary painters who, through self-edification, lift their art onto that higher plane. We hope that, through this extraordinary opportunity, artists will be liberated and emboldened to create more novel and appealing works. At the same time we firmly believe that this investment project was a wise and worthy decision, and that it is the most valuable and meaningful thing I, personally, have ever done.

Our collaboration with the Nanjing Museum and the contracted (or invited) artists has been an extremely enjoyable one. We are looking forward to the consolidation and expansion of this pleasant partnership!

图版目录

Contents

（画家顺序按姓氏笔画）

萧平作品

P20—31

01 莫奈与他的莲池
02 罗滕堡陶伯勃小官殿印象
03 渔村小景
04 塞尚如斯
05 马蒂斯自画像改作
06 花与女
07 新生的哭与笑
08 有瘾于烟者
09 寄情

庄天明作品

P46—57

01 头发胡子花白的眼镜
02 凡尔赛宫观光靓女
03 长发墨镜女郎
04 教皇古城的女佐罗
05 黑发欧洲妇女
06 阳光下海风中的金发女郎
07 斯图加特老者
08 黑发欧洲女郎
09 威尼斯所遇之大胡子
10 戴红眼镜女子

杨春华作品

P68—79

01 亚当与夏娃
02 永远的波堤切利
03 维纳斯诞生
04 受胎告知图
05 花神
06 春的女神
07 春的女神•波堤切利的女神
08 皮耶罗的经典
09 佳人携春风

丁方作品

P32—45

01 十二使徒面相——大雅各
02 十二使徒面相——约翰
03 十二使徒面相——彼得
04 十二使徒面相——安得烈
05 十二使徒面相——菲利普
06 十二使徒面相——巴塞洛缪
07 十二使徒面相——多马
08 十二使徒面相——犹大
09 十二使徒面相——西门
10 十二使徒面相——小雅各
11 十二使徒面相——马太
12 十二使徒面相——达太

杨彦作品

P58—67

01 天地和同
02 日月丽天
03 大爱无边
04 天必福之
05 天地之精
06 有情之人
07 相思之甚
08 山盟海誓

胡宁娜作品

P80—92

01 假面舞会•7个铃铛
02 假面舞会•红帽子
03 假面舞会•鞋子、兰帽子
04 假面舞会•贵妇人
05 假面舞会•扇子
06 假面舞会•魔镜
07 假面舞会•手套
08 假面舞会•18角帽子
09 假面舞会•高帽子
10 假面舞会•罗马钟
11 记忆假面舞会图

聂危谷作品

P94—105

01 君士坦丁凯旋门

02 玫瑰色调中的圣玛利亚教堂

03 圣彼得大教堂内景

04 许愿池

05 罗马宝鉴

06 共鸣巴洛克

07 天地间永恒的召唤

08 罗马之夜

09 水域诗韵

10 西班牙广场

常进作品

P116—124

01 巴黎的屋顶

02 马泰拉古城

03 暮光之城

04 阿玛菲海岸（一）

05 阿玛菲海岸（二）

06 阿玛菲海岸（三）

07 阿玛菲海岸（四）

徐乐乐作品

P106—114

01 肖像集卷二之一

02 肖像集卷二之二

03 肖像集卷二之三

04 忏悔中之玛德莱娜

05 圣马可祈祷图

06 主教大人祈求图

07 圣厄修拉梦中之天使

喻慧作品

P126—135

01 五角星花变种法国蔷薇

02 法国蔷薇"主教"

03 琉璃蔷薇

04 德阿莫玫瑰

05 切罗基玫瑰

06 秋季大马士革玫瑰

07 变种大蔷薇

08 变种包心玫瑰

Xiao Ping works
P20—31

01 Monet and His Pond
02 Impression of Small Palace in Rothenburg
ob der Tauber Tao Bobo
03 The View of Fishing Village
04 This Is Cezanne
05 Matisse Converted Self-portrait
06 Flowers and Woman
07 Newborn Crying and Laughter
08 People Addicted in Smoke
09 Focussed

Zhuang Tianming works
P46—57

01 Gray Hair and Beard with Glasses
02 Beauty Tour in Versailles
03 Sunglasses Girl with Long Hair
04 Female Zorro in Papal City
05 European Woman with Black Hair
06 Blonde under Sun in the Sea Breeze
07 Stuttgart Old
08 European Girl with Black Hair
09 Encountered with a Bearded in Venice
10 Woman with Red Glasses

Yang Chunhua works
P68—79

01 Adam and Eve
02 Forever Botticelli
03 Birth of Venus
04 Image of Impregnation
05 Flora
06 Goddess of Spring
07 Goddess of Spring•Goddess of Botticelli
08 Piero's Classic
09 Beauty with the Spring Breeze

Ding Fang works
P32—45

01 Face of Twelve Apostles - Jacob
02 Face of Twelve Apostles - John
03 Face of Twelve Apostles - Peter
04 Face of Twelve Apostles - Andrew
05 Face of Twelve Apostles - Philip
06 Face of Twelve Apostles - Bartholomew
07 Face of Twelve Apostles - Domar
08 Face of Twelve Apostles - Judas
09 Face of Twelve Apostles - Simon
10 Face of Twelve Apostles - Jacob
11 Face of Twelve Apostles - Matthew
12 Face of Twelve Apostles - Thaddaeus

Yang Yan works
P58—67

01 A Wedding between Heaven and Earth
02 Eternity
03 Boundless Love
04 Blessing of Heaven
05 Essence of Heaven and Earth
06 Lovers
07 Lovesickness
08 Pledge of Eternal Love

Hu Ningna works
P80—92

01 Masquerade•Seven Bells
02 Masquerade•Red Hat
03 Masquerade•Shoes, blue hat
04 Masquerade•Dame
05 Masquerade•Fan
06 Masquerade•Mirror
07 Masquerade•Gloves
08 Masquerade•18 Corner Hat
09 Masquerade•Tall Paper Hat
10 Masquerade•Rome Bell
11 Image of Masquerade in Memory

Nie Weigu works

P94—105

01 Arch of Constantine

02 The Church of St in Rose Color

03 St Peter's Interior

04 Trevi Fountain

05 Roman Treasures

06 Struck a Chord with Baroque

07 Summon between Heaven and Earth

08 Roman Nights

09 Waters of Poetry

10 The Spanish Square

Chang Jin works

P116—124

01 Rooftops of Paris

02 The Ancient City of Matera

03 Twilight

04 Amalfi Coast Ⅰ

05 Amalfi Coast Ⅱ

06 Amalfi Coast Ⅲ

07 Amalfi Coast Ⅳ

Xu Lele works

P106—114

01 Portrait Collection Volume 2 # 1

02 Portrait Collection Volume 2 # 2

03 Portrait Collection Volume 2 # 3

04 Madeline Lena in the Confession

05 Image of St. Mark's Prayer

06 Image of Bishop's Prayer

07 The Urban Seurat Dream of an Angel

Yu hui works

P126—135

01 Stapelia Variant of French Rose

02 "Bishop"-France Rose

03 Glass Rose

04 De Amo Rose

05 Cherokee Rose

06 Autumn Damask Rose

07 Variants Big Rose

08 Variant Roses Are in Bud

图版

Plate

萧平 （特邀）

1942年生于四川重庆，祖籍江苏扬州。1963年毕业于江苏省国画院。曾任书画鉴定之职于南京博物院十九年，1981年调江苏省国画院至今。现任江苏省国画院国家一级美术师，江苏省美学学会副会长，文化部艺术品评估委员会委员，故宫博物院客座研究员，江苏省第七、八、九届政协委员。

Xiao Ping (upon special invitation)
Born in 1942 in Chongqing, Sichuan, with ancestral lineage from Yangzhou, Jiangsu. He graduated from the Jiangsu Province Guohua Academy in 1963. He worked for 19 years as an art authenticator for the Nanjing Museum, but transferred to work at the Jiangsu Province Guohua Academy from 1981 to the present. There, he is currently a national-level artist, the vice president of the Jiangsu Province Institute of Aesthetics, a member of the Ministry of Culture's artistic assessment committee, a visiting fellow at the National Palace Museum, and a member of Jiangsu Province's seventh, eighth and ninth CPPCC.

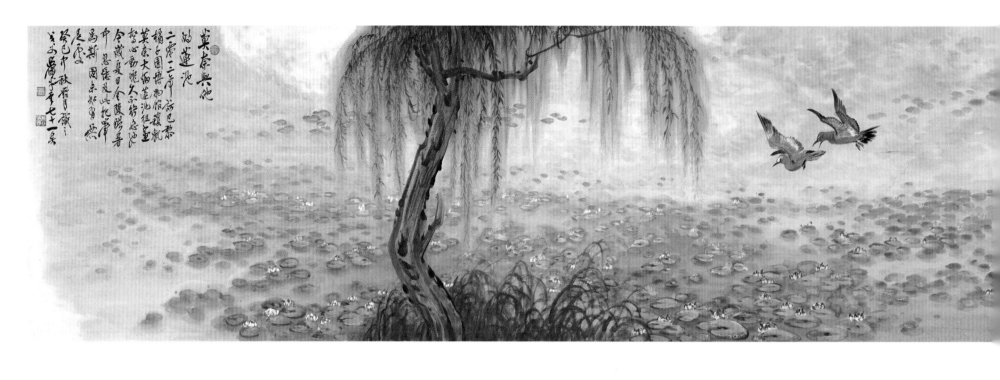

01 莫奈与他的莲池

Monet and His Pond

2013年

设色纸本

69cm×448cm

■ 款识

莫奈与他的莲池。2012年访巴黎橘子园博物馆，获观莫奈大幅莲池组画，惊心动魄，久不能忘也。今岁夏日，金陵酷暑中忽忆及此，把笔为斯图，未知有无是处。癸巳中秋对月识之。戈父萧平年七十一矣。

■ 钤印

双侠小阁（阳文）平之私玺（阳文）萧平写意（阴文）

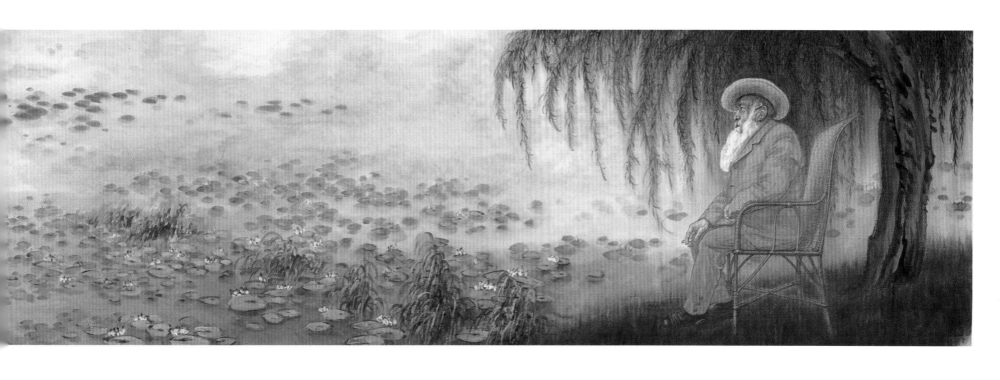

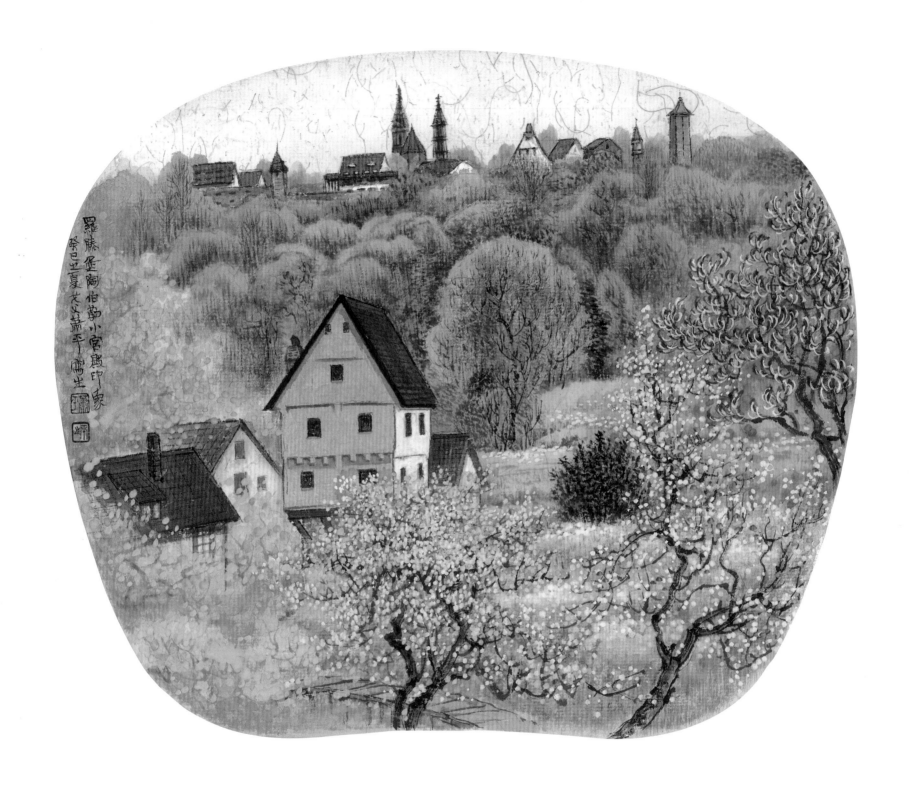

■ 02 罗滕堡陶伯勃小宫殿印象

Impression of Small Palace in Rothenburg ob der
Tauber Tao Bobo

2013年
设色纸本
28cm × 23cm

■ 款识
罗腾堡陶伯勒小宫殿印象。癸巳之夏,戈父萧平写生。
■ 钤印
萧平（阳文）平之（阳文）

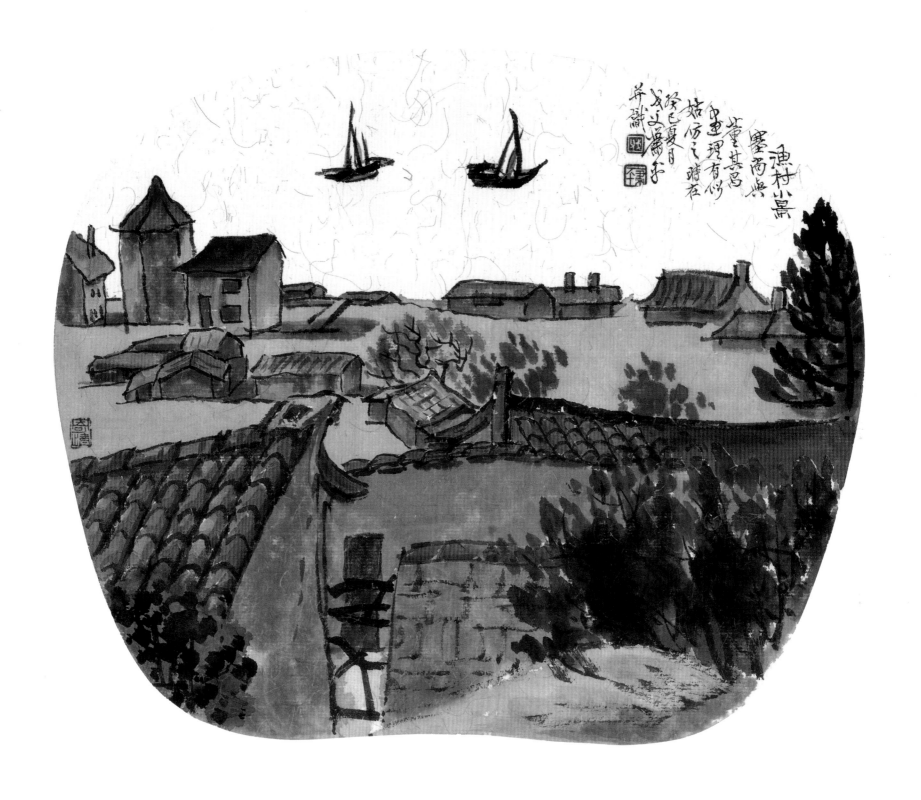

03 渔村小景

The View of Fishing Village

2013年

设色纸本

28cm×23cm

款识

渔村小景。塞尚与董其昌画理有似，姑仿之。时在癸巳夏月，戈父萧平并识。

钤印

戈父（阴文）萧平（阳文）

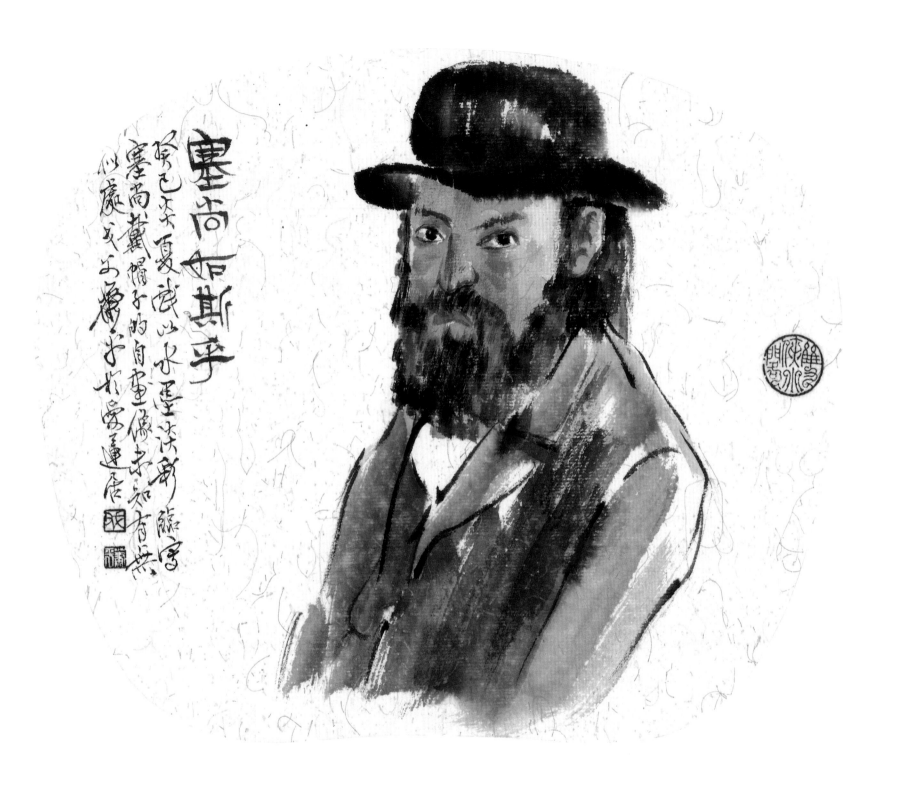

04 塞尚如斯

This Is Cezanne

2013年
镜片
28cm×23cm

■ 款识
塞尚如斯乎。癸巳炎夏戏以水墨淡彩临写《塞尚戴帽
子的自画像》，未知有无似处。戈父萧平于爱莲居。

■ 钤印
戈父（阳文）萧平（阴文）双侠小阁（阳文）

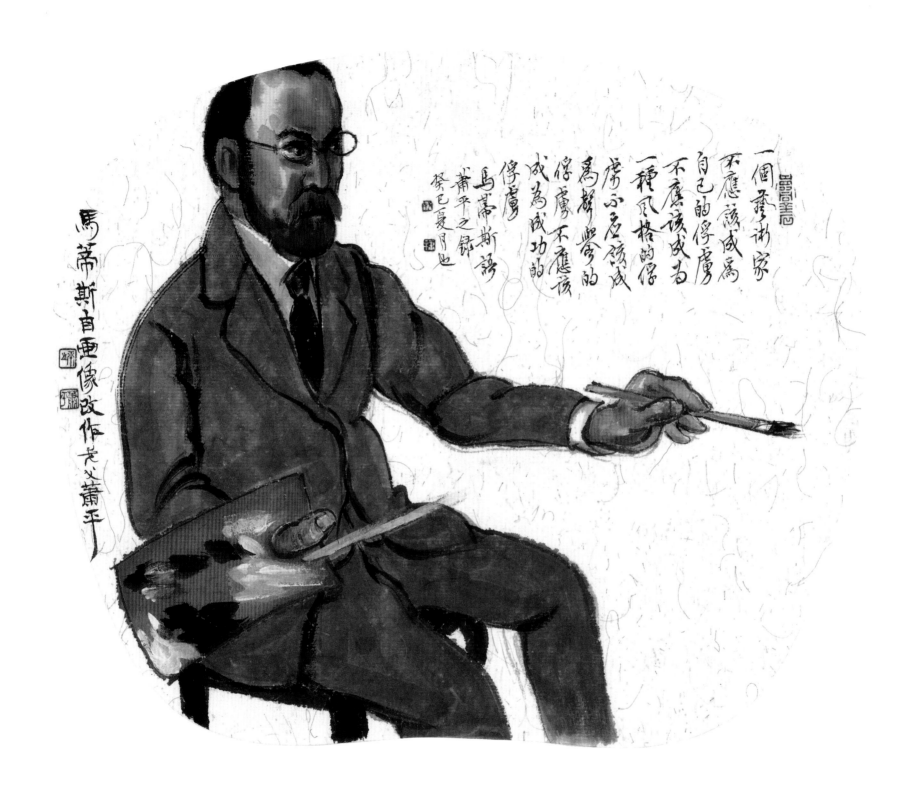

一個藝術家
不應該成為
自己的俘虜
不應該成為
一種風格的俘
虜不應該成
為聲譽的
俘虜不應該
成為成功的
俘虜
馬蒂斯語
蕭平之錄
癸巳夏月也

馬蒂斯自畫像改作戈父蕭平

■ 05 马蒂斯自画像改作

Matisse Converted Self-portrait

2013年
镜片
28cm×23cm

■ 款识
马蒂斯自画像改作。戈父萧平。
一个艺术家不应该成为自己的俘虏,不应该成为一种风格的俘虏,不应该
成为声誉的俘虏,不应该成为成功的俘虏。马蒂斯语,萧平之录,癸巳夏
月也。
■ 钤印
平之(阳文)萧平(阳文)寿同金石(阳文)戈父(阳文)萧平(阴文)

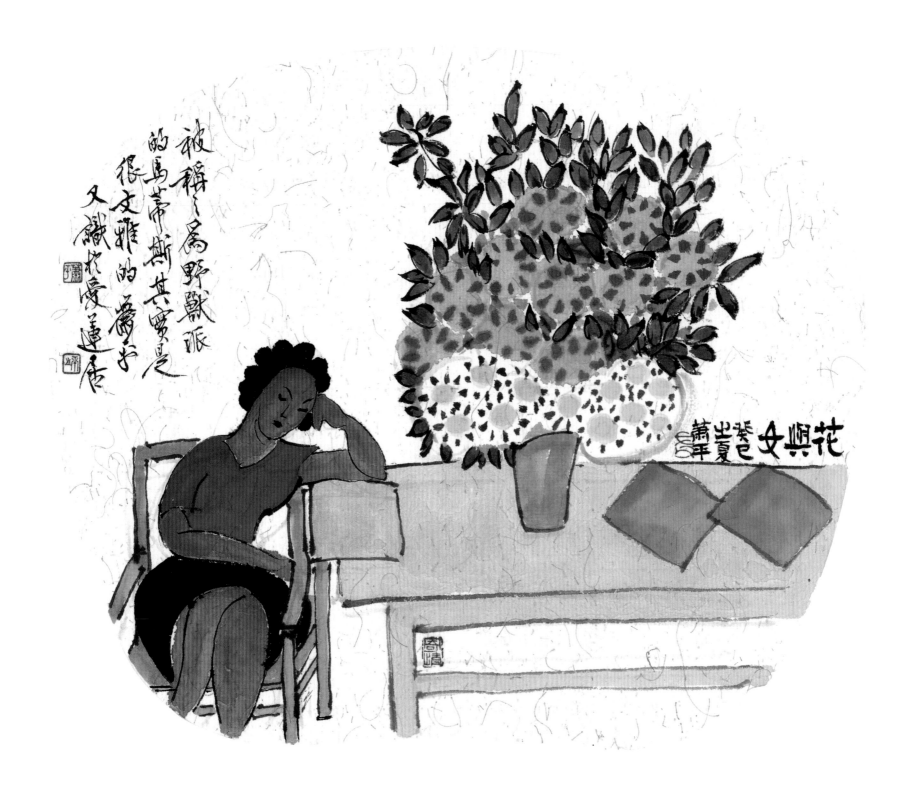

■ 06 花与女
Flowers and Woman

2013年
镜片
28cm×23cm

■ 款识
花与女。癸巳之夏，萧平。
被称之为野兽派的马蒂斯，其实是很文雅的。萧平又识于爱莲居

■ 钤印
戈父（阳文）萧平（阳文）平之（阳文）寄情（阳文）

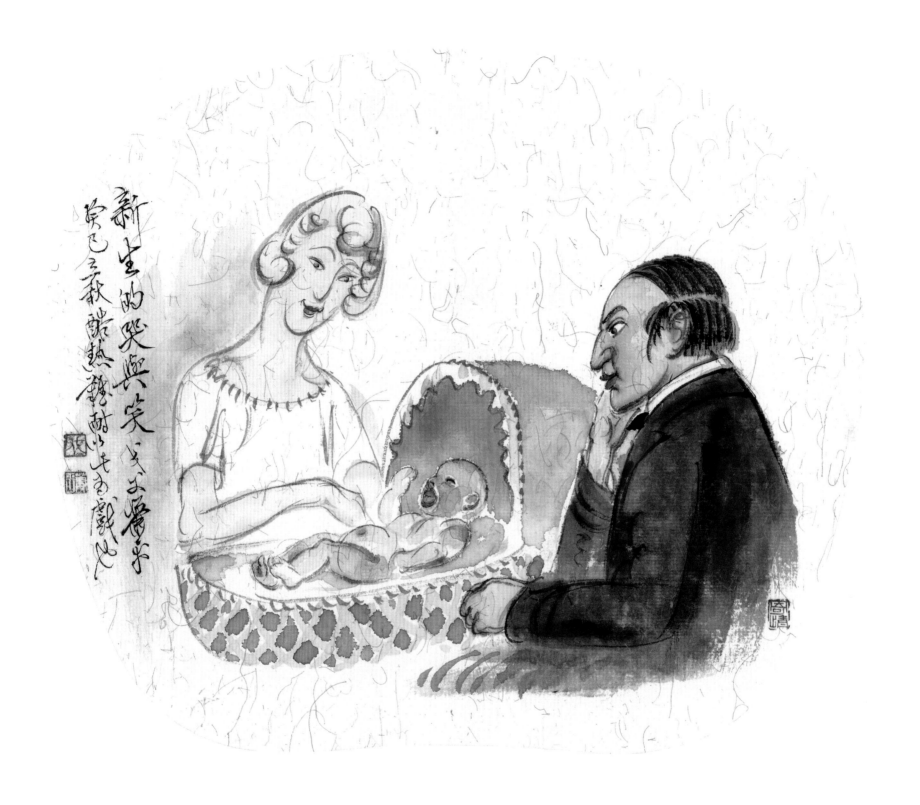

■ 07 新生的哭与笑

Newborn Crying and Laughter

2013年
设色纸本
28cm × 23cm

■ 款识
新生的哭与笑。戈父萧平，癸巳立秋，酷热难耐，以此为戏也。

■ 钤印
戈父（阳文）萧平（阴文）寄情（阳文）

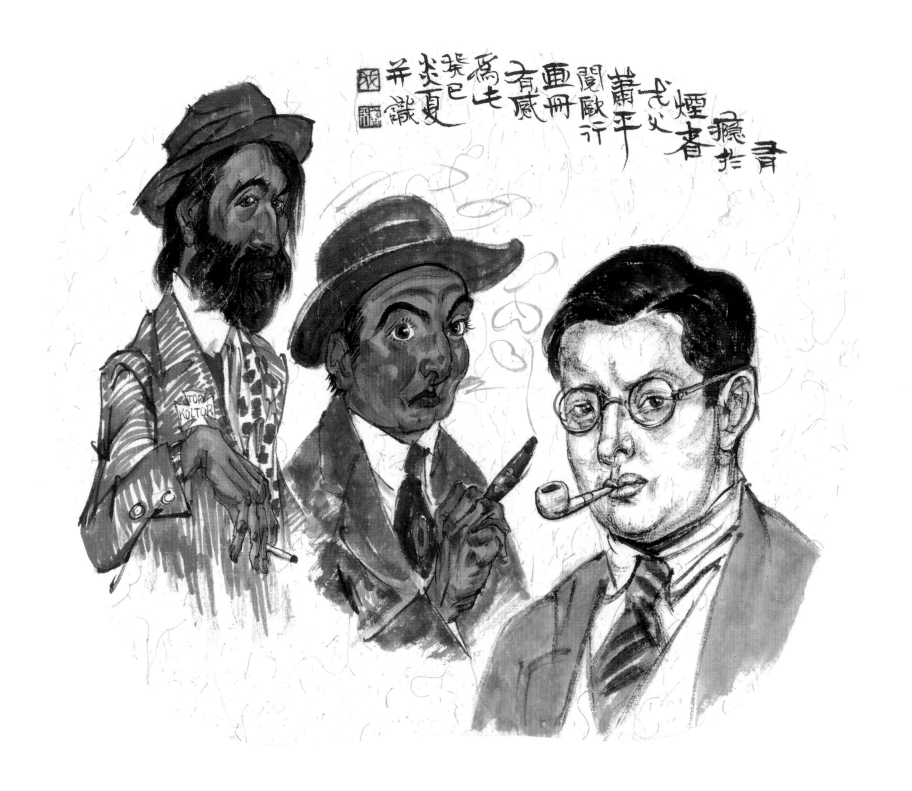

■ 08 有瘾于烟者

People Addicted in Smoke

2013年

镜片

28cm × 32cm

■ 款识

有瘾于烟者。戈父萧平阅欧行画册，有感

为此。癸巳炎夏并识。

■ 钤印

戈父（阳文）萧平（阴文）

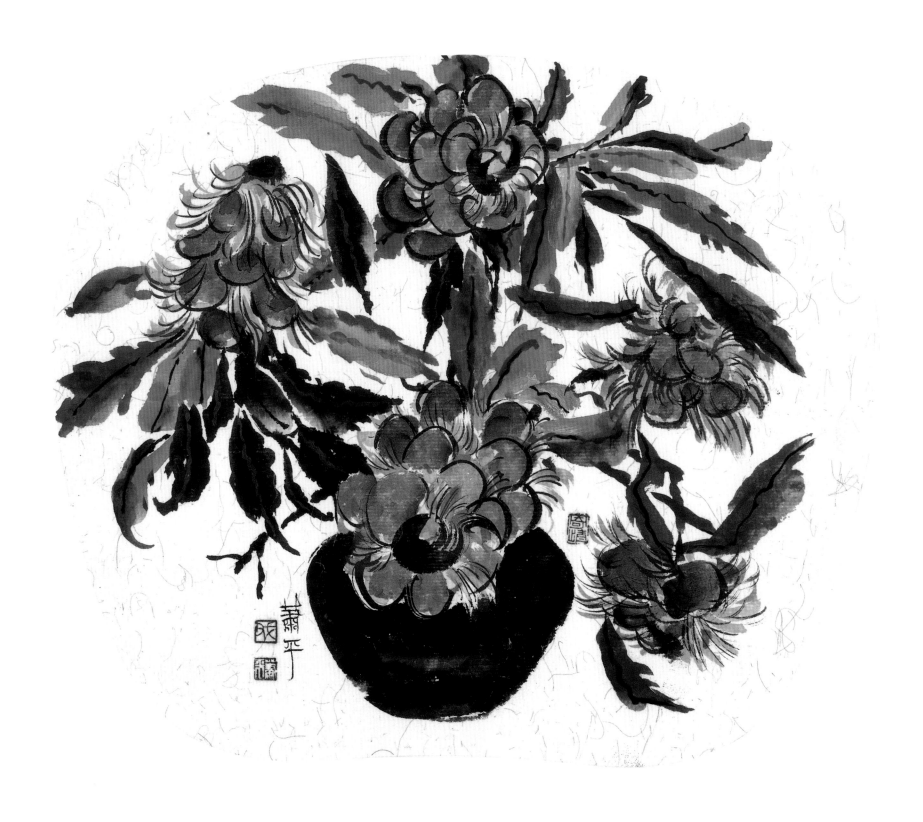

09 寄情

Focussed

2013年
设色纸本
28cm × 23cm

款识
萧平。
钤印
寄情（阳文）戈父（阳文）萧平（阴文）

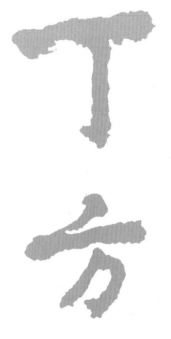

丁方

1956年生于江苏。1982年毕业于南京艺术学院工艺美术系。1983年攻读该院
美术系油画专业研究生，并留校任教。现为中国人民大学艺术学院教授、博
士生导师。

Ding Fang

Mr. Ding was born in Jiangsu,1956. He graduated from the Department of
Industrial Art, Nanjing Arts Institute in 1982. He studied on the M.A. program
of oil painting in the same department in 1983 and then became a teacher
there. Now he is a professor and Ph.D. supervisor in the Academy of Fine Arts,
Renmin University of China.

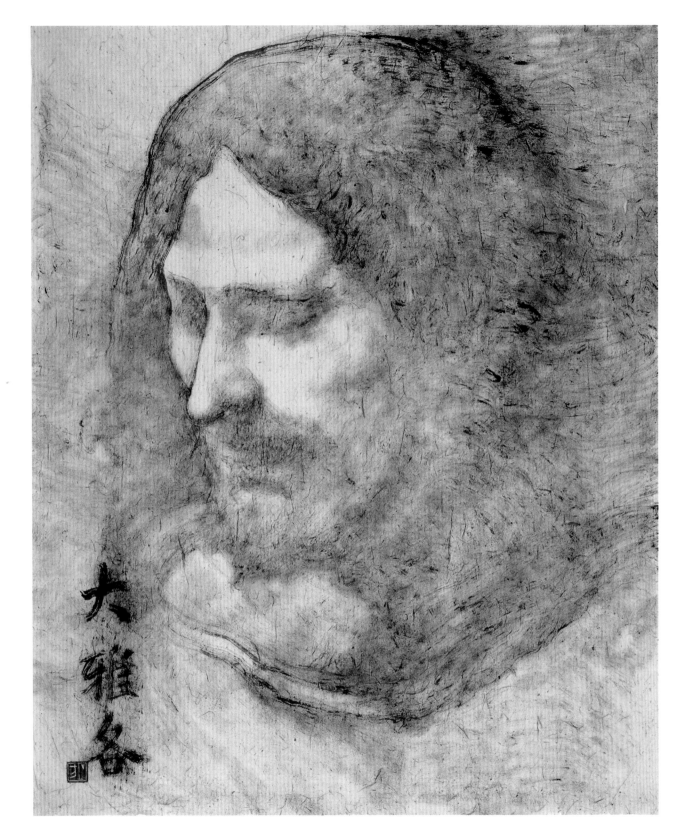

■ 01 十二使徒面相——大雅各

Face of Twelve Apostles - Jacob

2013年
水墨纸本
116cm × 97cm

■ 款识
大雅各.
■ 钤印
丁方（阴文）

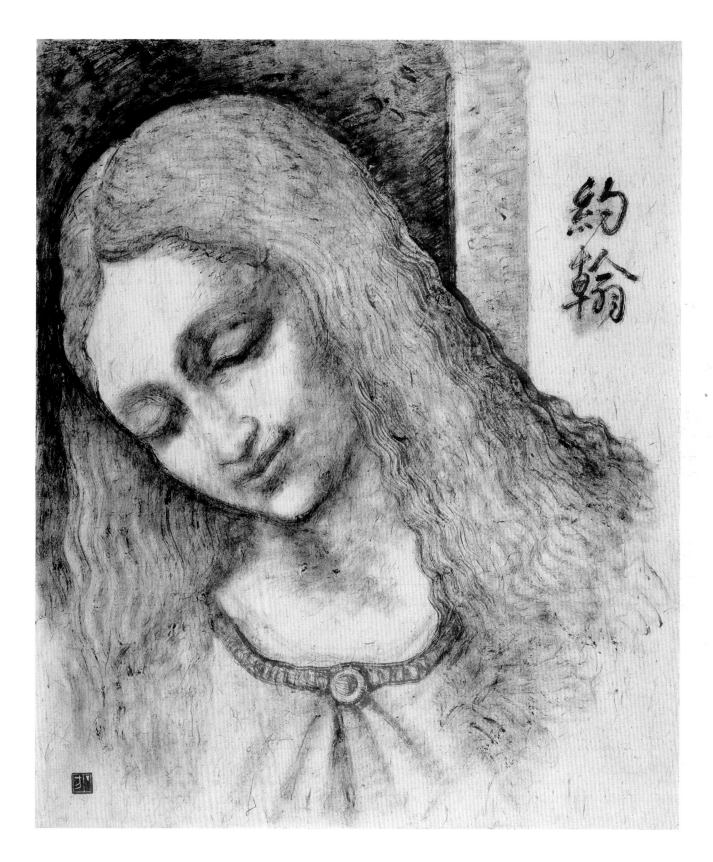

■ 02 十二使徒面相——约翰

Face of Twelve Apostles - John

2013年
水墨纸本
116cm×97cm

■ 款识
约翰。
■ 钤印
丁方（阴文）

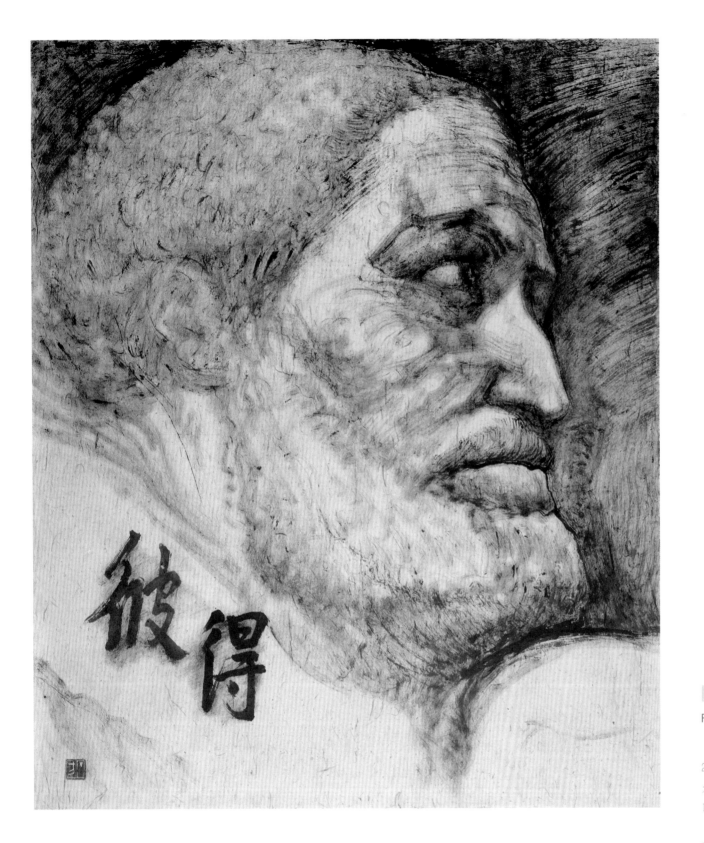

03 十二使徒面相——彼得

Face of Twelve Apostles - Peter

2013年
水墨纸本
116cm×97cm

款识
彼得。
钤印
丁方（阴文）

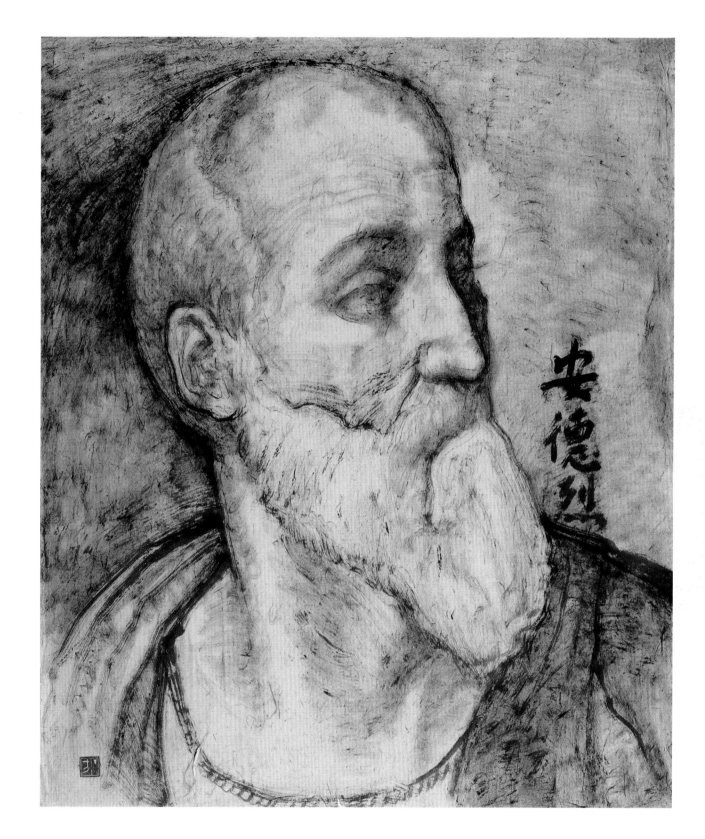

04 十二使徒面相——安得
烈

Face of Twelve Apostles - Andrew

2013年
水墨纸本
116cm × 97cm

款识
安得烈。
钤印
丁方（阴文）

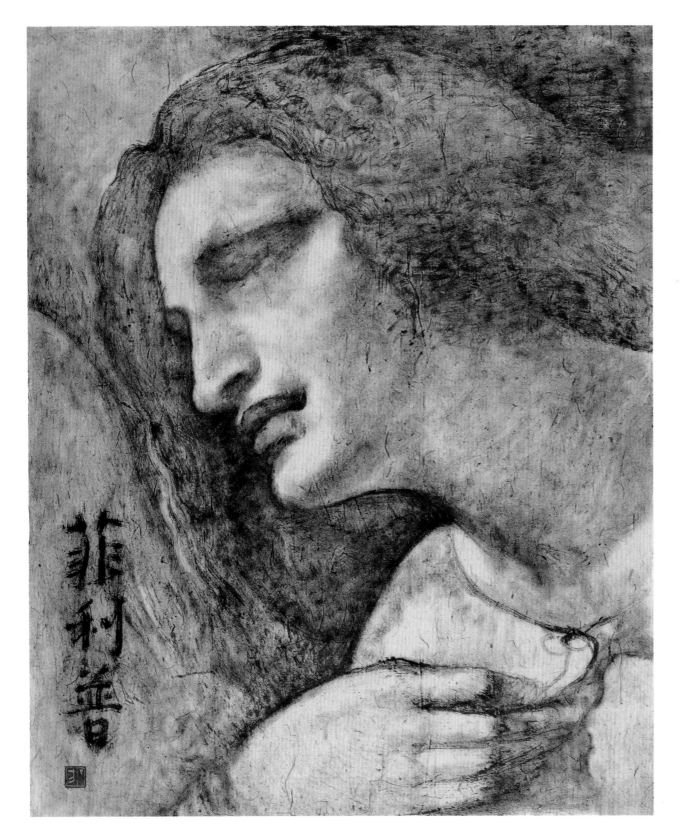

■ 05 十二使徒面相——菲利普

Face of Twelve Apostles - Philip

2013年
水墨纸本
116cm × 97cm

■ 款识
菲利普。
■ 钤印
丁方（阴文）

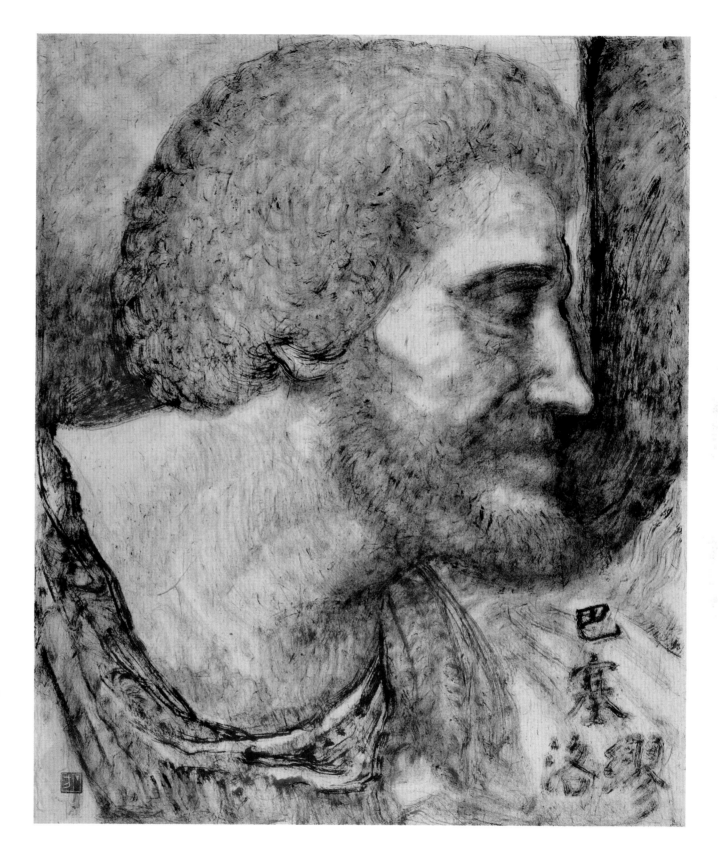

06 十二使徒面相——巴塞洛缪

Face of Twelve Apostles - Bartholomew

2013年
水墨纸本
116cm×97cm

款识
巴塞洛缪。
钤印
丁方（阴文）

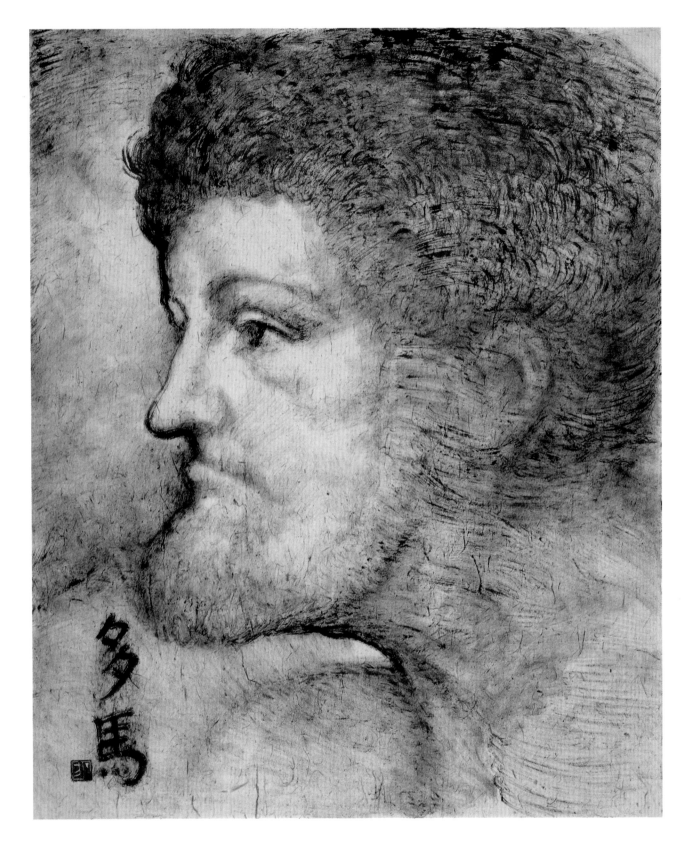

■ 07 十二使徒面相——多马

Face of Twelve Apostles - Domar

2013年
水墨纸本
116cm × 97cm

■ 款识
多马。
■ 钤印
丁方（阴文）

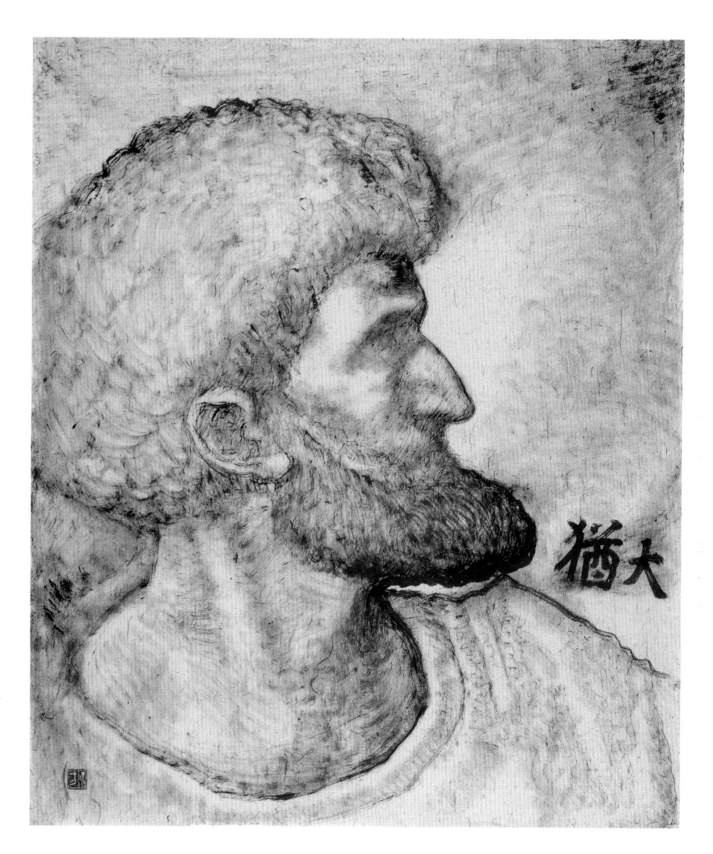

■ 08 十二使徒面相——犹大

Face of Twelve Apostles - Judas

2013年
水墨纸本
116cm×97cm

■ 款识
犹大。
■ 钤印
丁方（阴文）

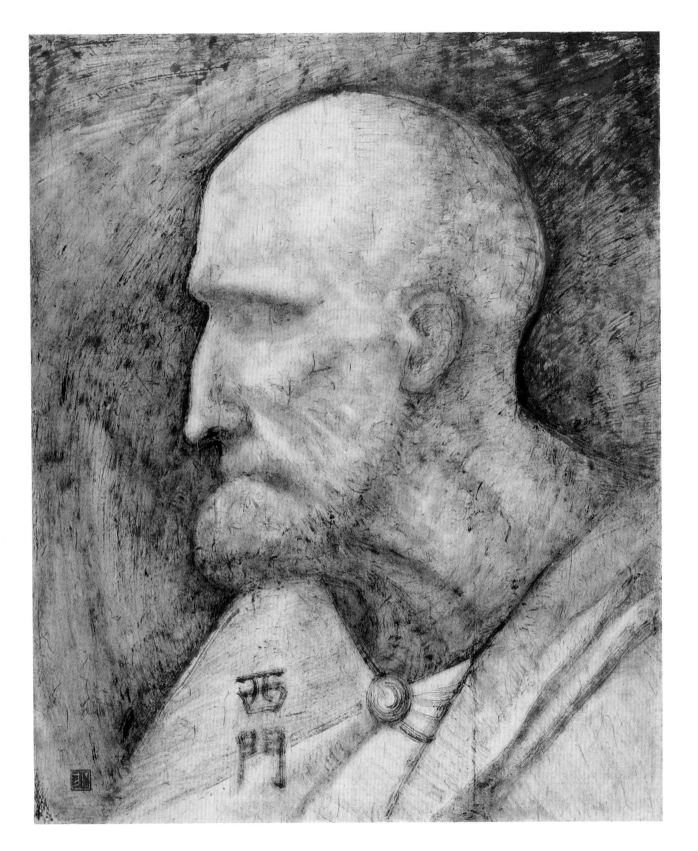

■ 09 十二使徒面相——西门

Face of Twelve Apostles - Simon

2013年
水墨纸本
116cm×97cm

■ 款识
西门。
■ 钤印
丁方（阴文）

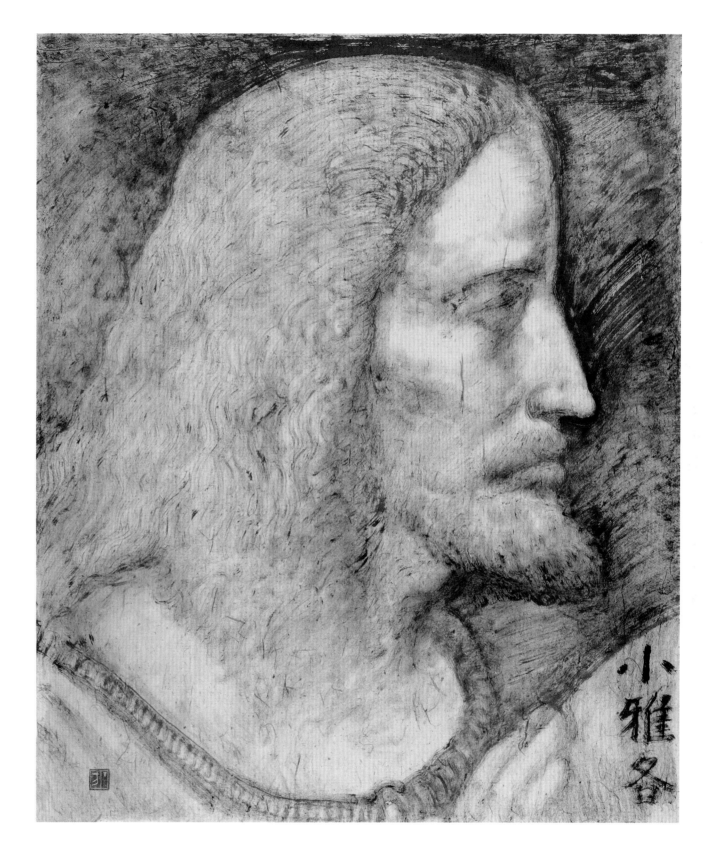

■ 10 十二使徒面相——小
雅各
Face of Twelve Apostles - Jacob

2013年
水墨纸本
116cm×97cm

■ 款识
小雅各。
■ 钤印
丁方（阴文）

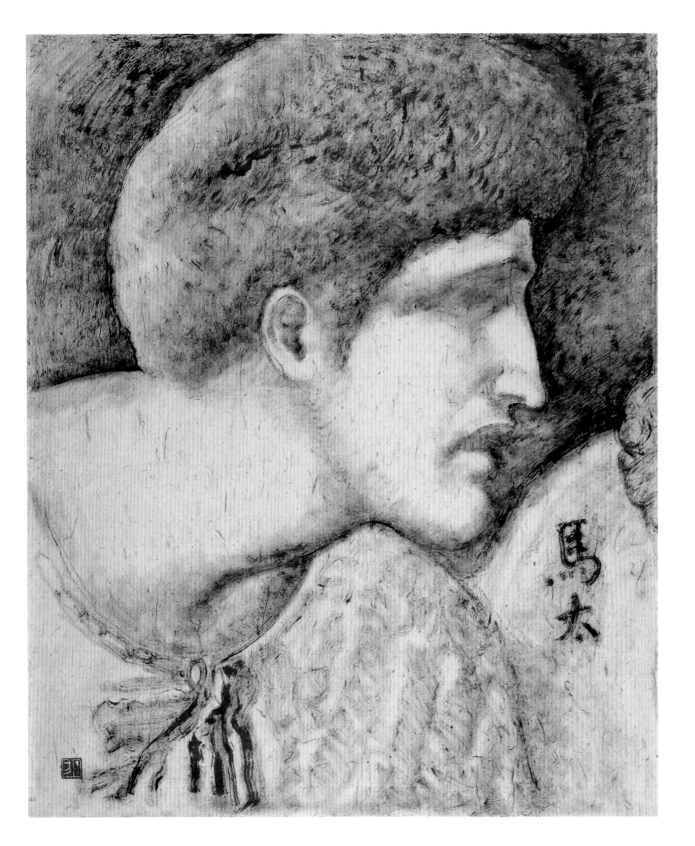

■ 11 十二使徒面相——马太

Face of Twelve Apostles - Matthew

2013年
水墨纸本
116cm×97cm

■ 款识
马太。
■ 钤印
丁方(阴文)

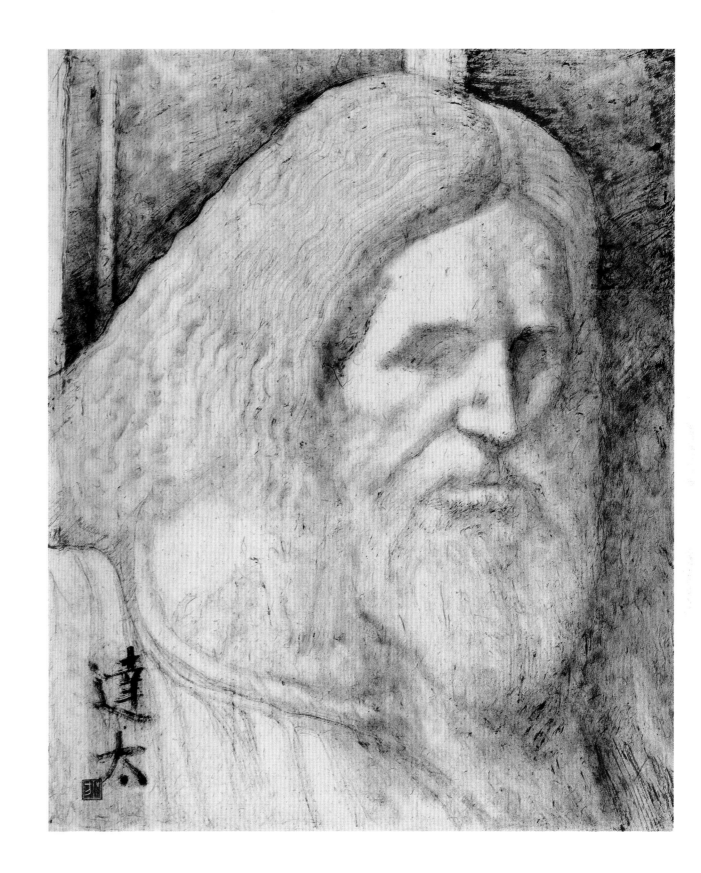

12 十二使徒面相——达太

Face of Twelve Apostles - Thaddaeus

2013年
水墨纸本
116cm×97cm

■ 款识
达太。
■ 钤印
丁方（阴文）

庄天明

1954年出生于江苏无锡。1981年毕业于南京师范大学美术学院，获文学学士学位。现任南京博物院艺术研究所所长，中国书法家协会会员。

Zhuang Tianming

Mr. Zhuang was born in Wuxi, Jiangsu in 1954. He graduated from the School of Fine Arts, Nanjing Normal University, with a B.A. degree in 1981. Now he is the director of the Art Research Institute of Nanjing Museum and a member of China Calligraphers Association.

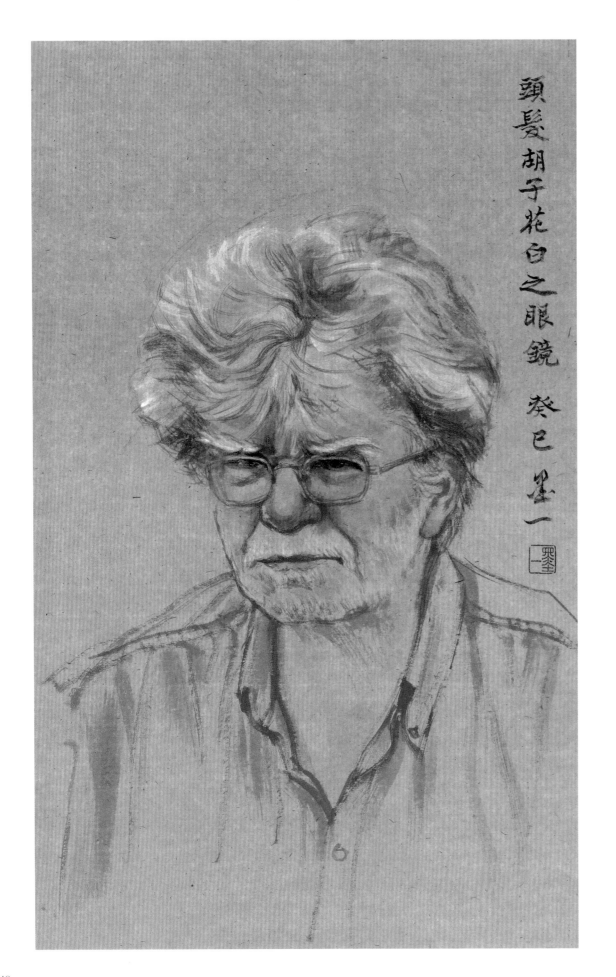

頭髮鬍子花白之眼鏡 癸巳 墨一

01 头发胡子花白的眼镜

Gray Hair and Beard with Glasses

2013年
设色纸本
77cm × 48cm

■ 款识
头发胡子花白之眼镜。癸巳，墨一。
■ 钤印
墨一(阳文)

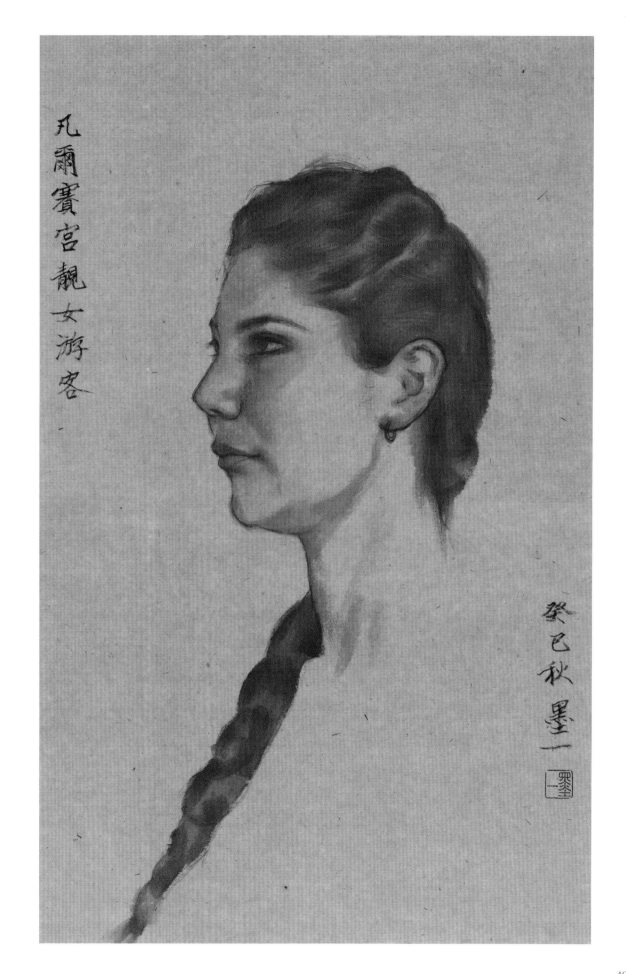

凡爾賽宮靚女遊客

癸巳秋 墨一

02 凡尔赛宫观光靓女

Beauty Tour in Versailles

2013年
设色纸本
77cm × 48cm

■ 款识
凡尔赛宫靓女游客。癸巳秋，墨一。
■ 钤印
墨一(阳文)

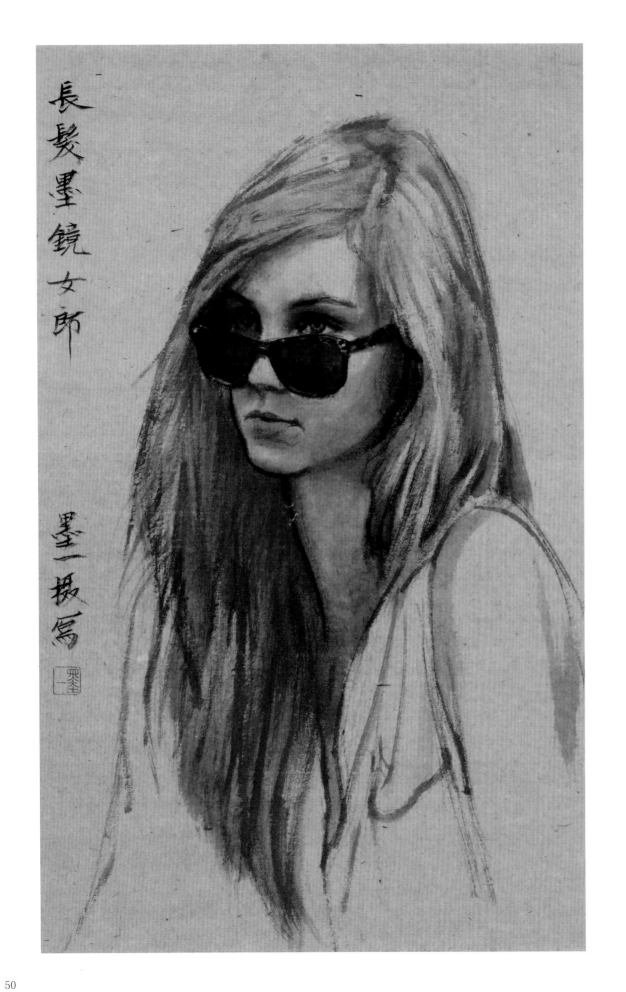

03 长发墨镜女郎

Sunglasses Girl with Long Hair

2013年
设色纸本
77cm × 48cm

■ 款识
长发墨镜女郎。墨一摄写。
■ 钤印
墨一(阳文)

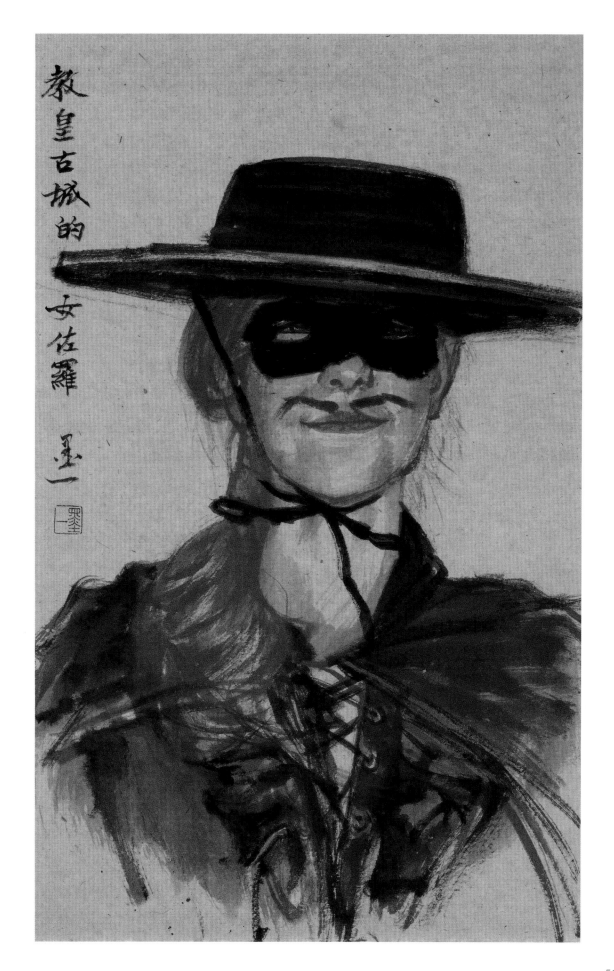

04 教皇古城的女佐罗

Female Zorro in Papal City

2013年
设色纸本
77cm × 48cm

款识
教皇古城的女佐罗。墨一。
钤印
墨一(阳文)

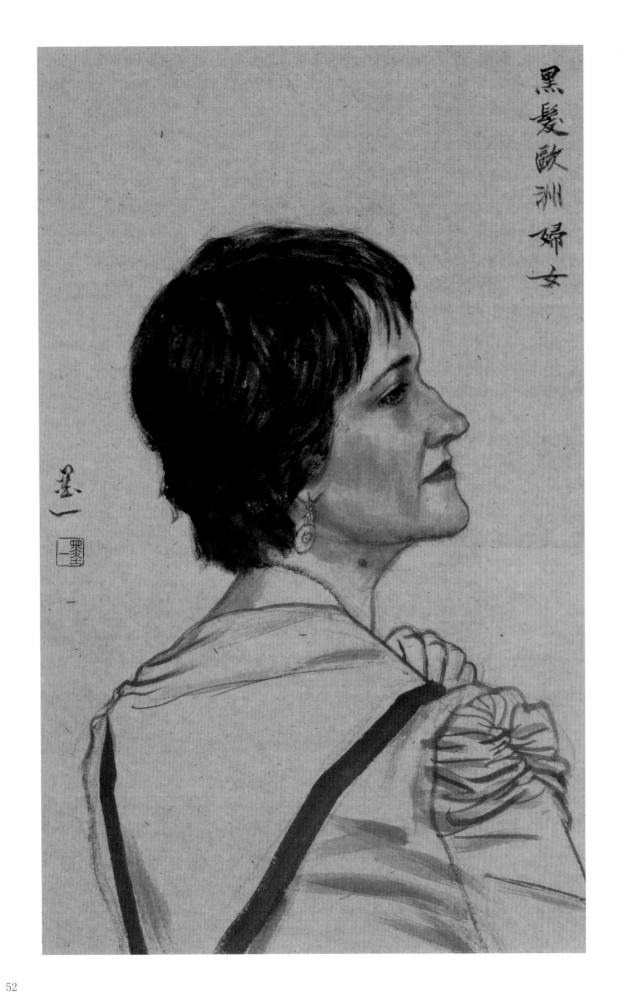

黑髮歐洲婦女

■ 05 黑发欧洲妇女

European Woman with Black Hair

2013年
设色纸本
77cm × 48cm

■ 款识
黑发欧洲妇女。墨一。
■ 钤印
墨一(阳文)

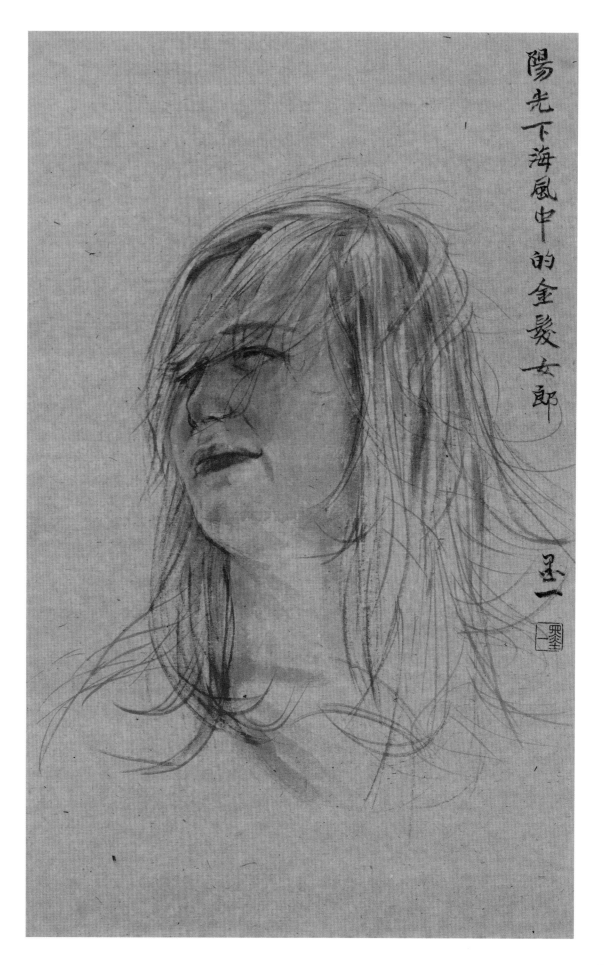

陽光下海風中的金髮女郎

墨一

06 阳光下海风中的金发女郎

Blonde under Sun in the Sea Breeze

2013年
设色纸本
77cm × 48cm

款识
阳光下海风中的金发女郎。墨一。
钤印
墨一(阳文)

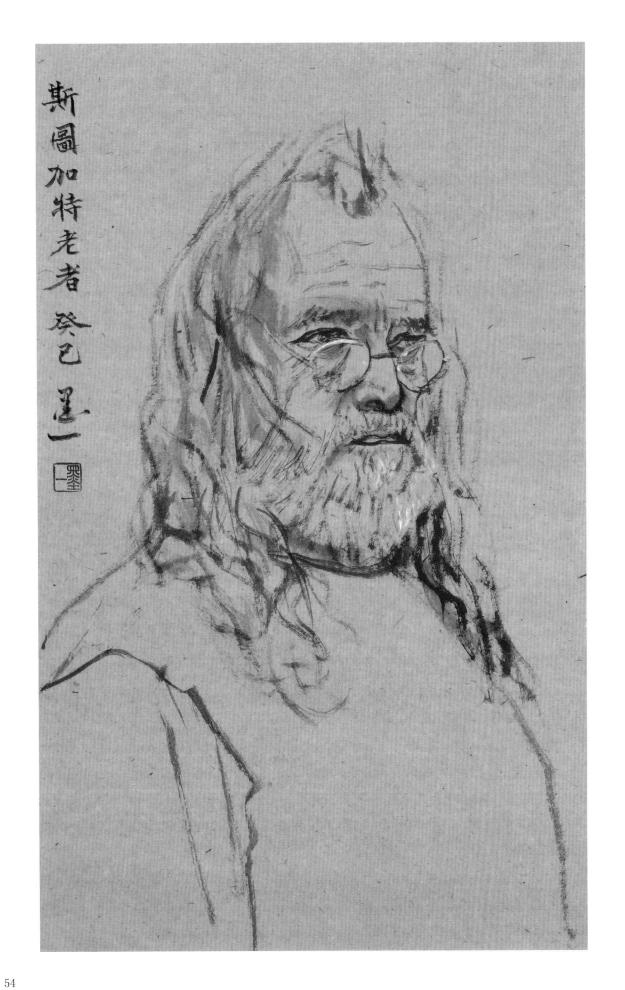

斯圖加特老者 癸巳 墨一

07 斯图加特老者

Stuttgart Old

2013年
设色纸本
77cm × 48cm

■ 款识
斯图加特老者。癸巳，墨一。
■ 钤印
墨一(阳文)

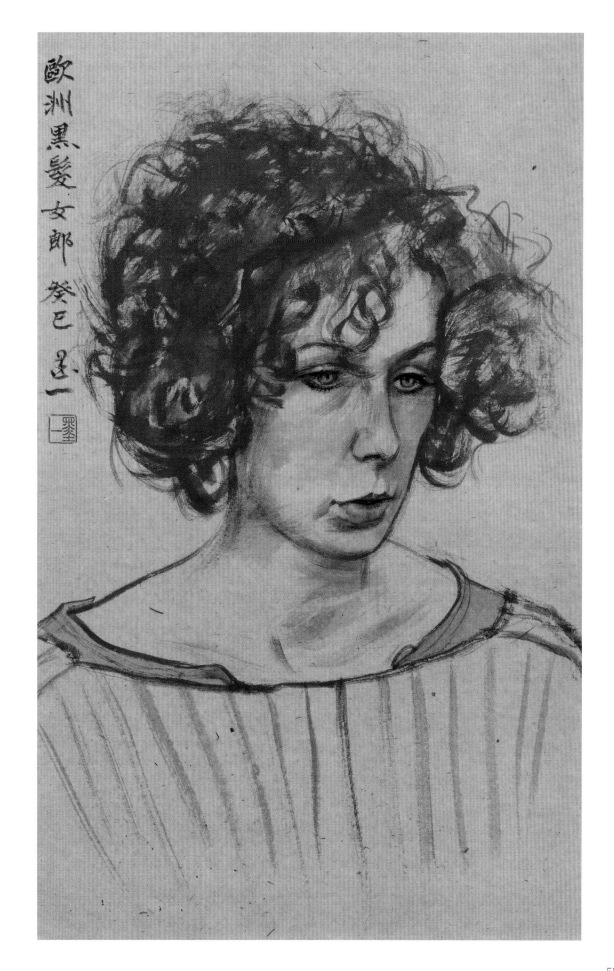

08 黑发欧洲女郎

European Girl with Black Hair

2013年
设色纸本
77cm×48cm

■ 款识
黑发欧洲女郎。癸巳,墨一。
■ 钤印
墨一(阳文)

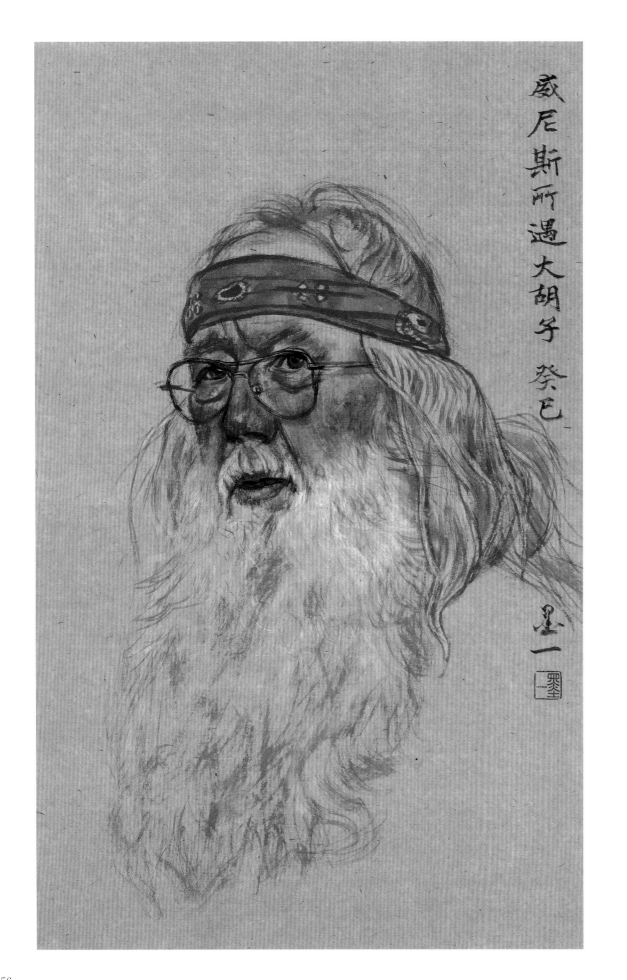

威尼斯所遇大胡子 癸巳

墨一

09 威尼斯所遇之大胡子

Encountered with a Bearded in Venice

2013年
设色纸本
77cm × 48cm

款识
威尼斯所遇大胡子。墨一。
钤印
墨一(阳文)

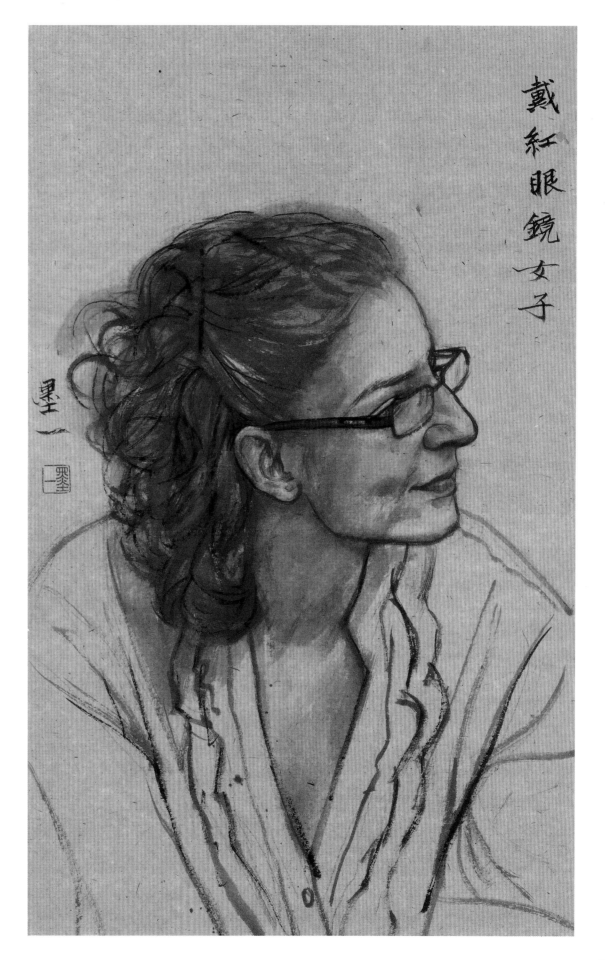

戴红眼镜女子

■ 10 戴红眼镜女子

Woman with Red Glasses

2013年
设色纸本
77cm × 48cm

■ 款识
戴红眼镜女子。墨一。
■ 钤印
墨一(阳文)

杨彦

1958年生于青海。现为中国美术家协会会员，北大资源美术学院教授，中国民族画院副院长，南京博物院客座研究员。

Yang Yan

Mr. Yang was born in Qinghai in 1958. Now he is a member of China Artists Association, a professor of the School of Resources and Art, Beijing University. He is also the vice dean of the Academy of China National Arts and a guest researcher of Nanjing Museum.

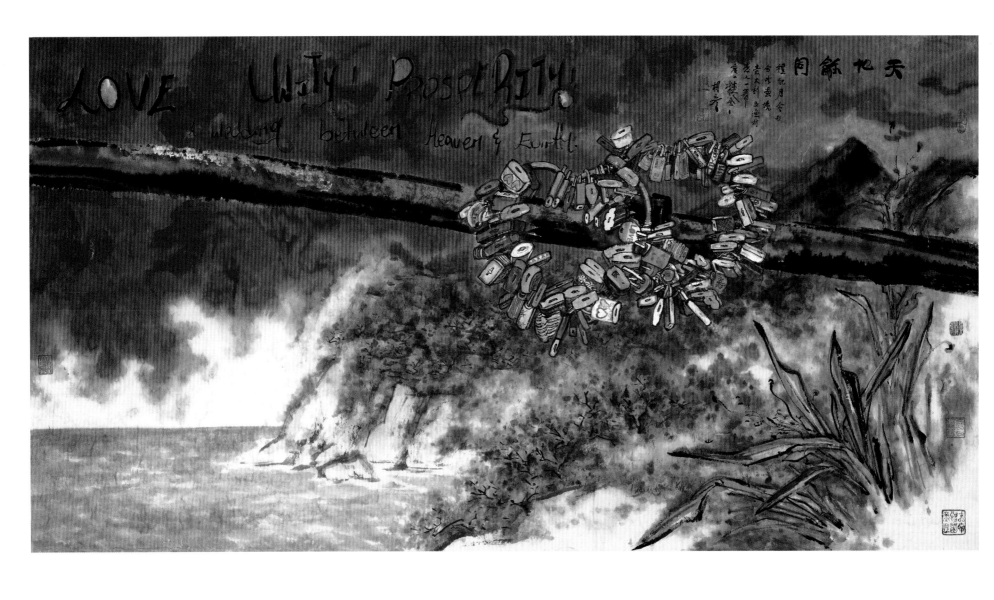

■ 01 天地和同

A Wedding between Heaven and Earth

2013年
设色纸本
99cm×189cm

■ 款识
天地和同。《礼记·月令》句，合此画境。意大利五渔村感人一幕。度一精舍杨彦。
■ 铃印
太和之气（阳文）度一精舍（阳文）杨彦书画（阴文）

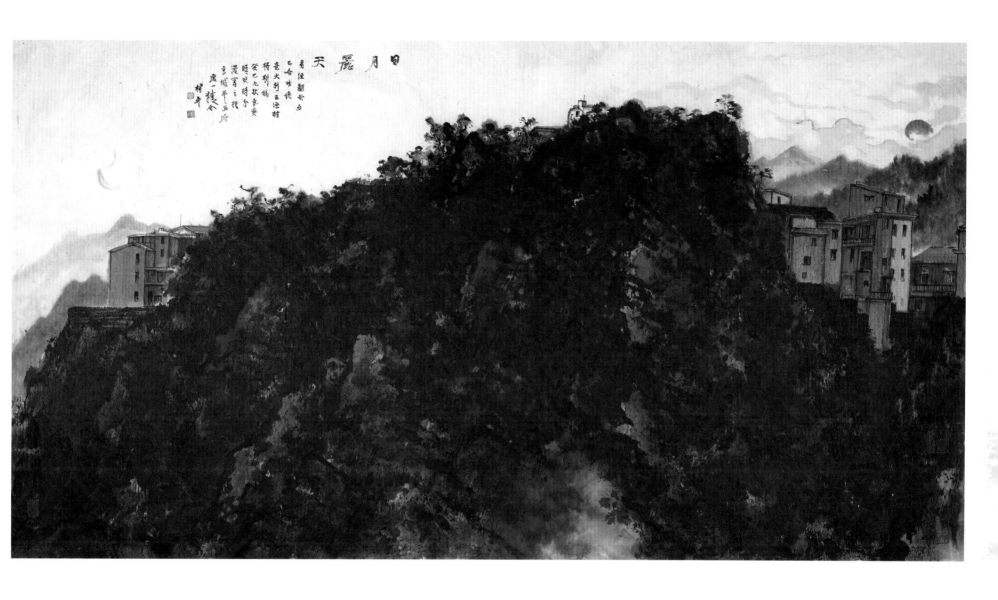

02 日月丽天

Eternity

2013年
设色纸本
99cm×187.5cm

款识

日月丽天。《易经·离卦》句，正合此境，意大利五渔村得斯稿。癸巳九秋，气爽晴晚时分漫写之于京城平西府度一精舍，杨彦。

钤印

养一（阴文）自在快乐金刚（阳文）杨（阳文）杨彦（阴文）

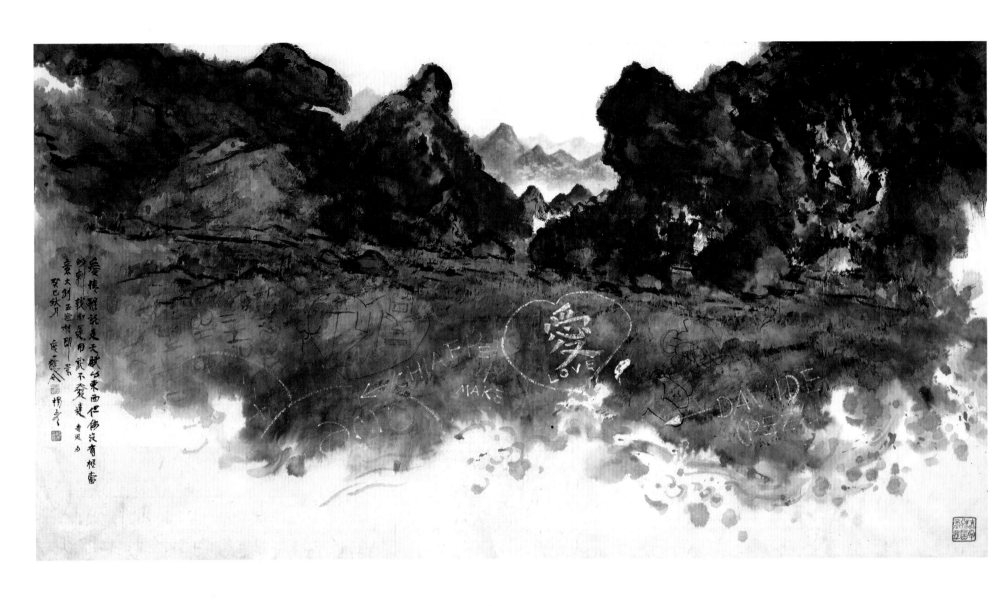

■ 03 大爱无边

Boundless Love

2013年
设色纸本
99cm×190cm

■ 款识
爱情虽说是天赋的东西，但倘没有相当的刺戟和
运用，就不发达。鲁迅句。意大利五渔村即景。
癸巳秋月，度一精舍杨彦。

■ 钤印
太和之气（阳文）杨（阳文）杨彦印信（阴文）
结人间翰墨缘（阴文）自在快乐金刚（阳文）

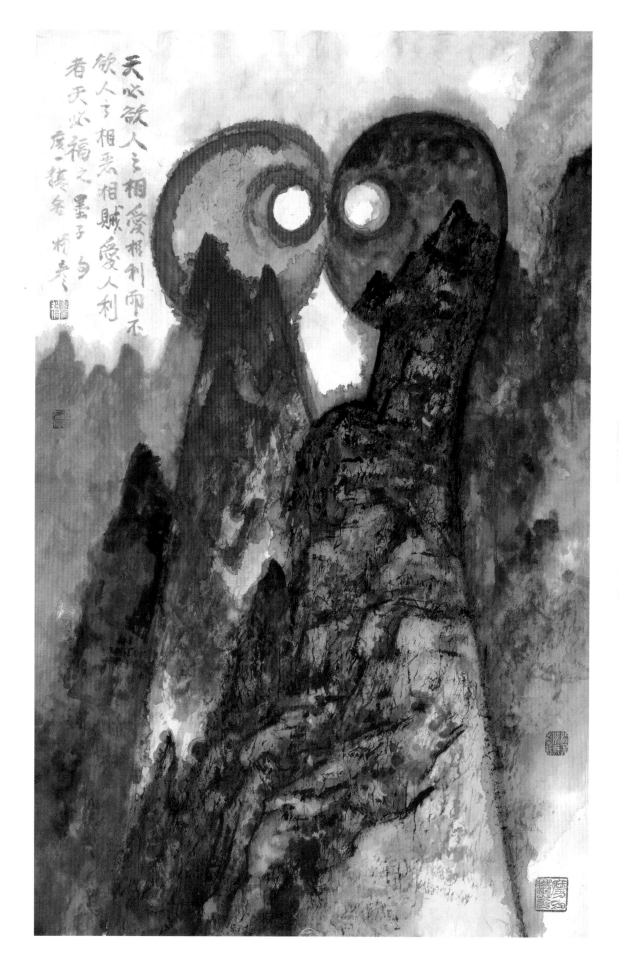

04 天必福之

Blessing of Heaven

2013年
设色纸本
99.5cm × 64cm

■ 款识
天必欲人之相爱相利，而不欲人相恶相贼。爱人利
者，天必福之。墨子句。度一精舍杨彦。
■ 钤印
杨彦印信（阳文）得自在禅（阴文）太和之气（阳
文）结人间翰墨缘（阴文）度一精舍（阳文）

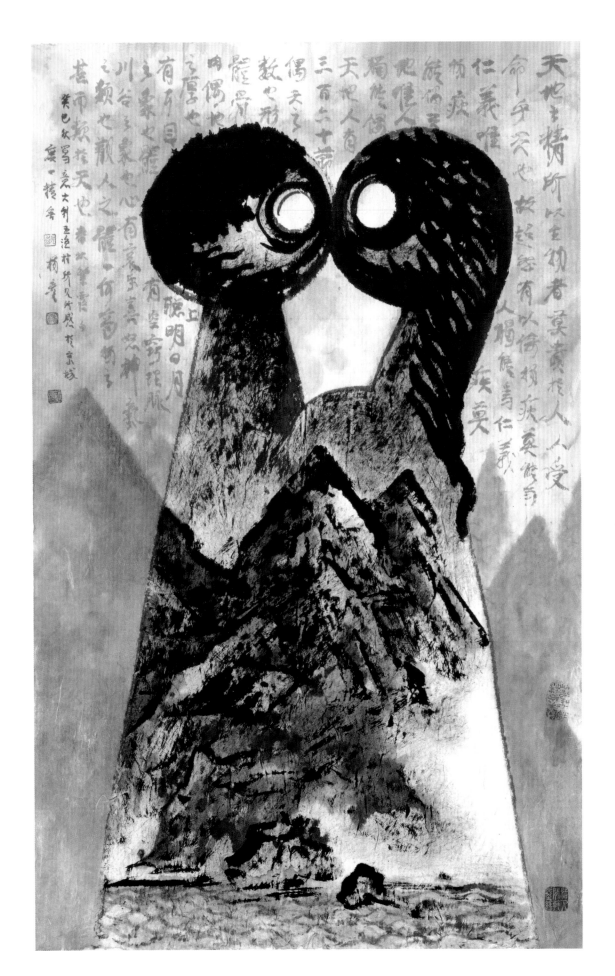

05 天地之精

Essence of Heaven and Earth

2013年
设色纸本
99.5cm × 62cm

款识

天地之精所以生物者，莫贵于人。人受命乎天也，故超然有以倚。物疢疾莫能为仁义，唯人独能为仁义。物疢疾莫能偶天地，唯人独能偶天地。人有三百六十节，偶天之数也；形体骨肉偶地之厚也。上有耳目聪明日月之象也。体有空窍理脉川谷之象也。心有哀乐喜怒神气之类也。观人之体一何高物之甚，而类于天也。春秋繁露句。癸巳秋，写意大利五渔村所见所感于京城，度一精舍杨彦。

钤印

长寿（阳文）杨（阳文）杨彦（阴文）与天地精神往还（阳文）结人间翰墨缘（阴文）

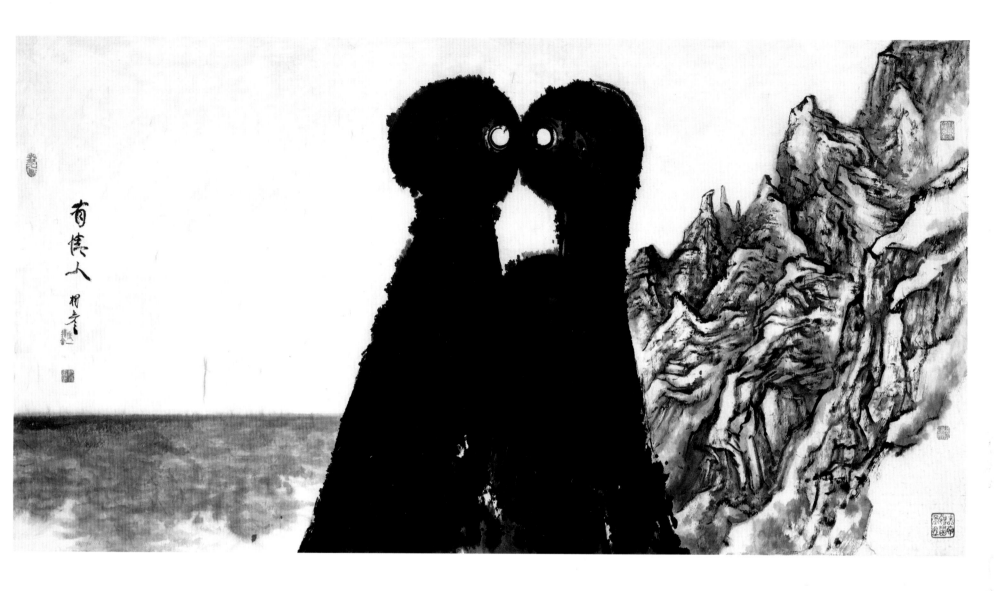

■ 06 有情之人

Lovers

2013年
设色纸本
98.5cm×190cm

■ 款识
有情人。杨彦。
■ 钤印
度一精舍（阳文）杨彦书画（阴文）太和之气
（阳文）乐未央（阳文）结人间翰墨缘（阴文）
自在快乐金刚（阳文）

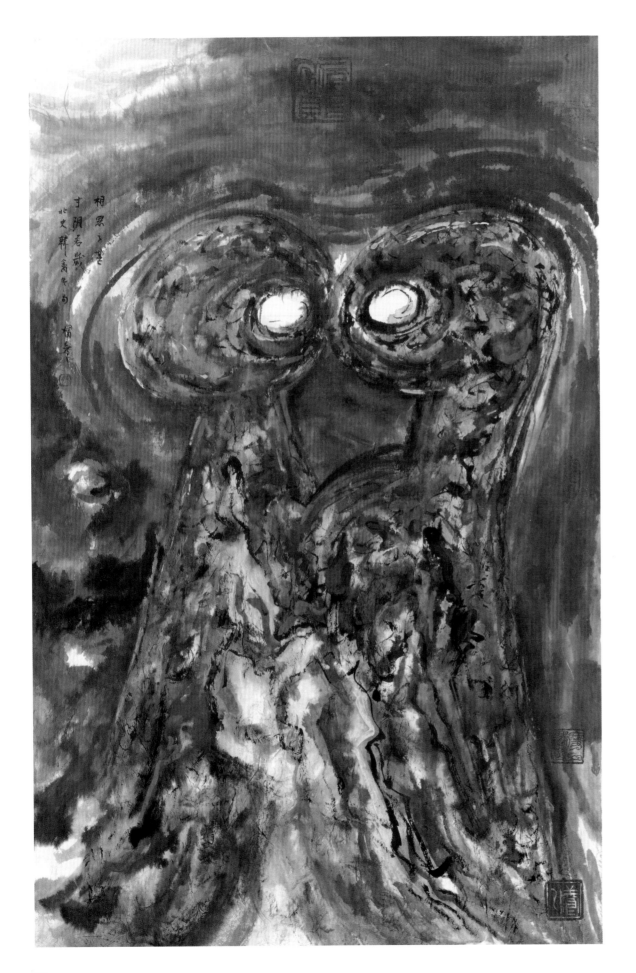

■ 07 相思之甚

Lovesickness

2013年
设色纸本
99.5cm × 64cm

■ 款识
永远的波堤切利。金陵春华写。2013。
■ 钤印
春华画印（阳文）好颜色（阳文）春老
花生（阴文）

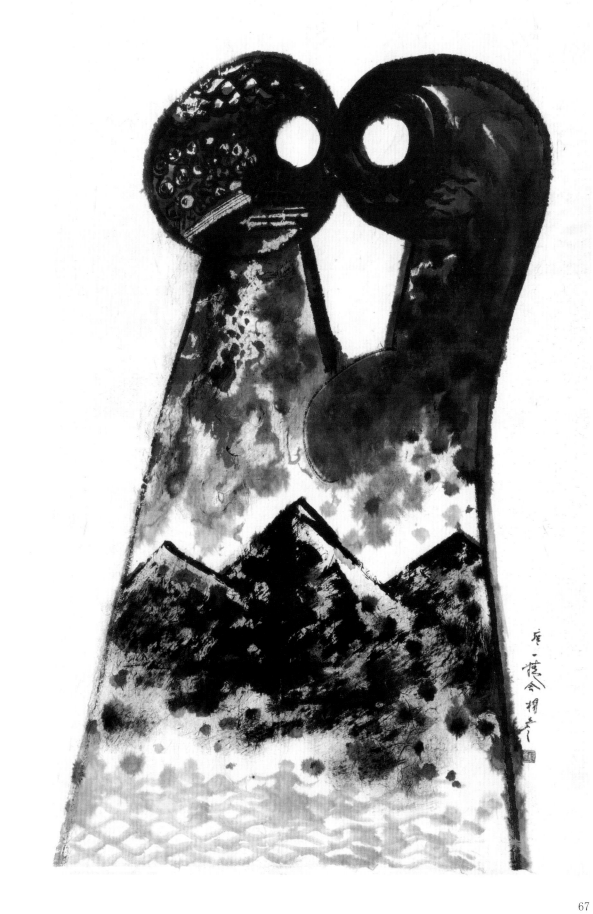

08 山盟海誓
Pledge of Eternal Love

2013年
设色纸本
99.5cm×62cm
■ 款识
度一精舍，杨彦。
■ 钤印
杨彦（阴文）

杨春华

1953年生于南京，祖籍浙江温州。1976年毕业于南京艺术学院美术系版画专业；1980年毕业于中央美术学院版画系研究生班。1981年至1988年任无锡书画院副院长，现为南京艺术学院美术学院教授、硕士生导师，中国美术家协会会员，中国版画家协会理事。

Yang Chunhua

Mr. Yang was born in Nanjing in 1953, her ancestral home being Wenzhou, Zhejiang. In 1976 she graduated from Nanjing Arts Institute majoring in graphic art. In 1980 she finished her study in the postgraduate course of China Central Academy of Fine Arts. She had served as vice dean of Wuxi Academy of Painting and Calligraphy from 1981-1988. Now she is a professor and M.A. supervisor in Nanjing Arts Institute. She is also a member of China Artists Association and a board member of China Graphic Artists Association.

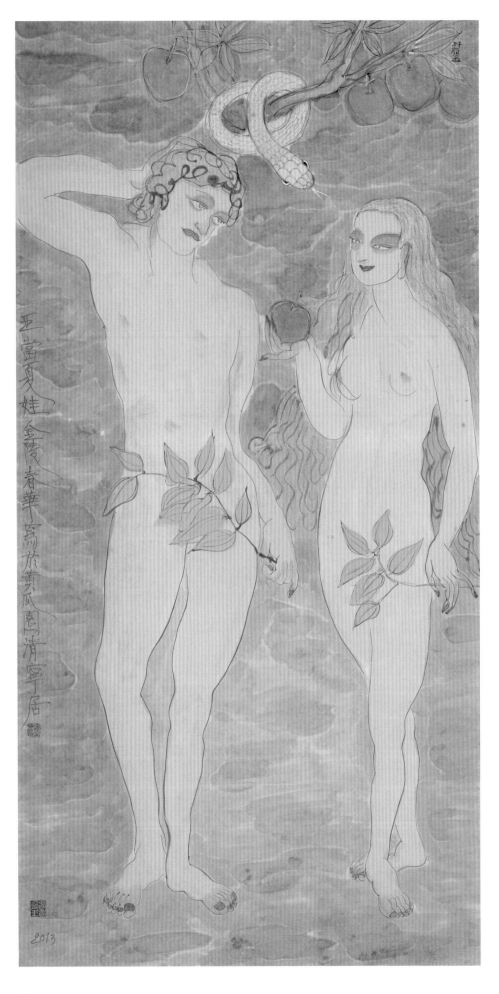

■ 01 亚当与夏娃

Adam and Eve

2013年
设色纸本
137cm × 69.5cm

■ 款识
亚当夏娃。金陵春华写于黄瓜园清宁居。
2013。

■ 钤印
春华画印（阳文）

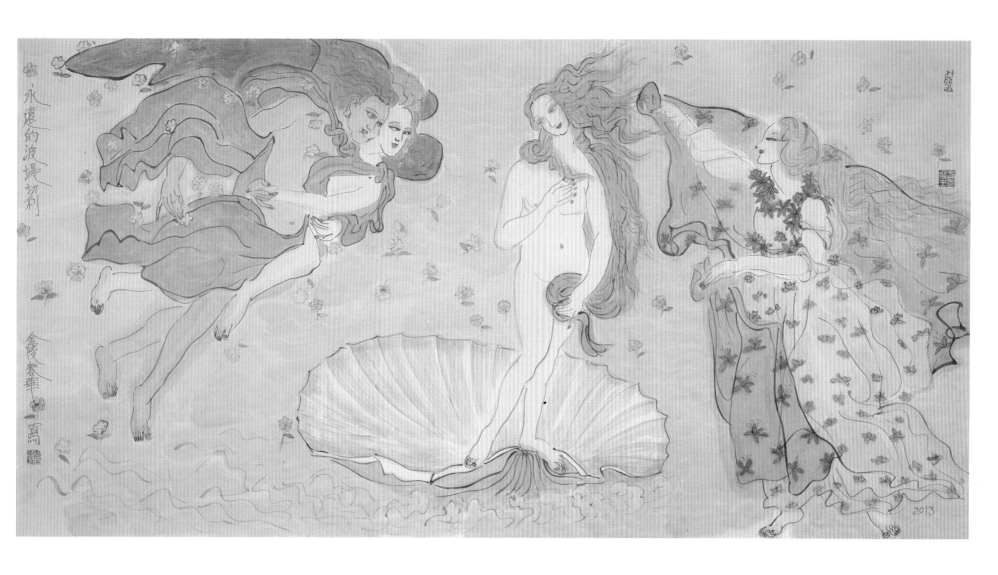

02 永远的波堤切利

Forever Botticelli

2013年
设色纸本
69.5cm×137cm

■ 款识
永远的波堤切利。金陵春华写。2013。
■ 钤印
春华画印（阳文）好颜色（阳文）春老
花生（阴文）

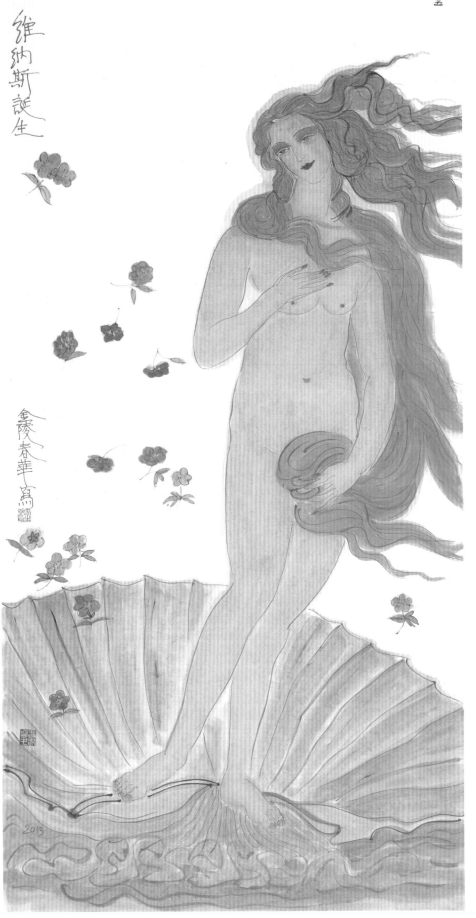

■ 03 维纳斯诞生

Birth of Venus

2013年
设色纸本
137cm×69.5cm

■ 款识
维纳斯诞生，金陵春华写。2013。
■ 钤印
春华画印（阳文）春老花生（阴文）

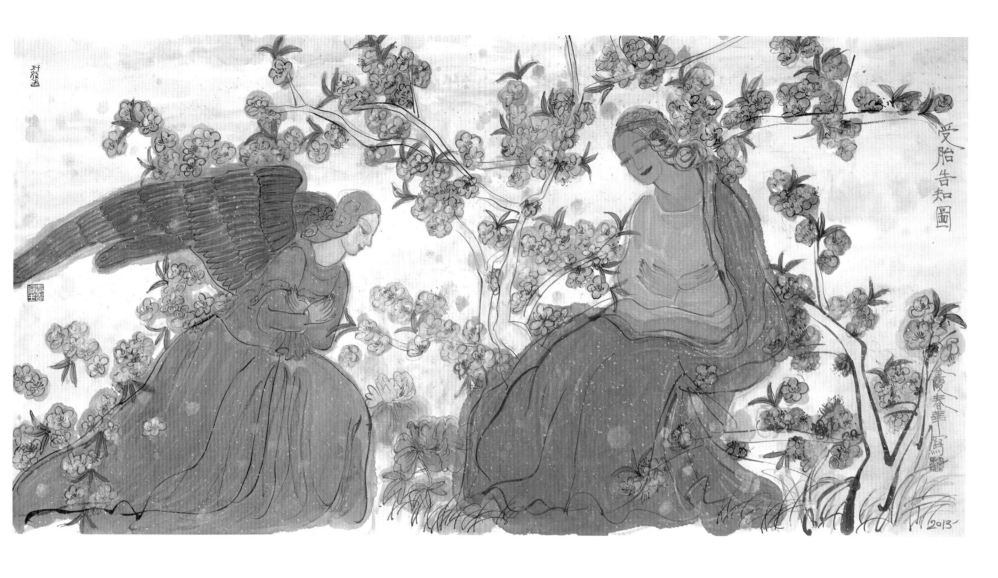

04 受胎告知图

Image of Impregnation

2013年
设色纸本
68cm×134.5cm

■ 款识
受胎告知图，金陵春华写。2013。

■ 铃印
春华画印（阳文）好颜色（阳文）
春老花生（阴文）

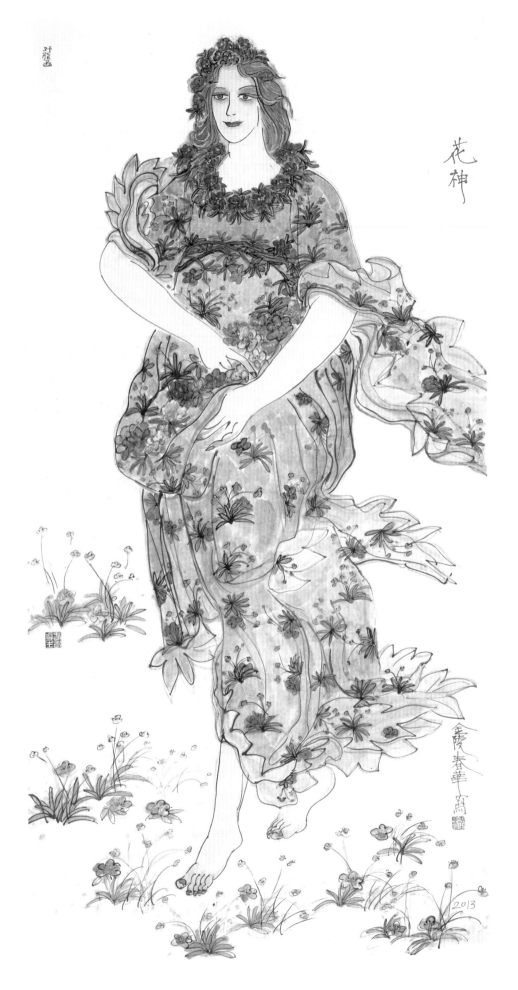

花神

■ 05 花神

Flora

2013年
设色纸本
137cm×69.5cm

■ 款识
花神，金陵春华写。2013。
■ 钤印
春华画印（阳文）好颜色（阳文）
春老花生（阴文）

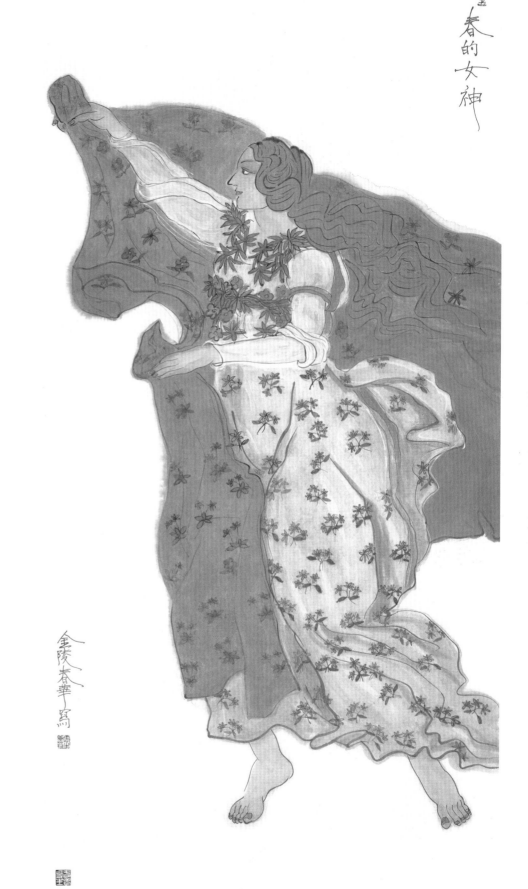

春的女神

06 春的女神

Goddess of Spring

2013年
设色纸本
137cm×69.5cm

■ 款识
春的女神，金陵春华写。2013。
■ 钤印
春华画印（阳文）好颜色（阳文）
春老花生（阴文）

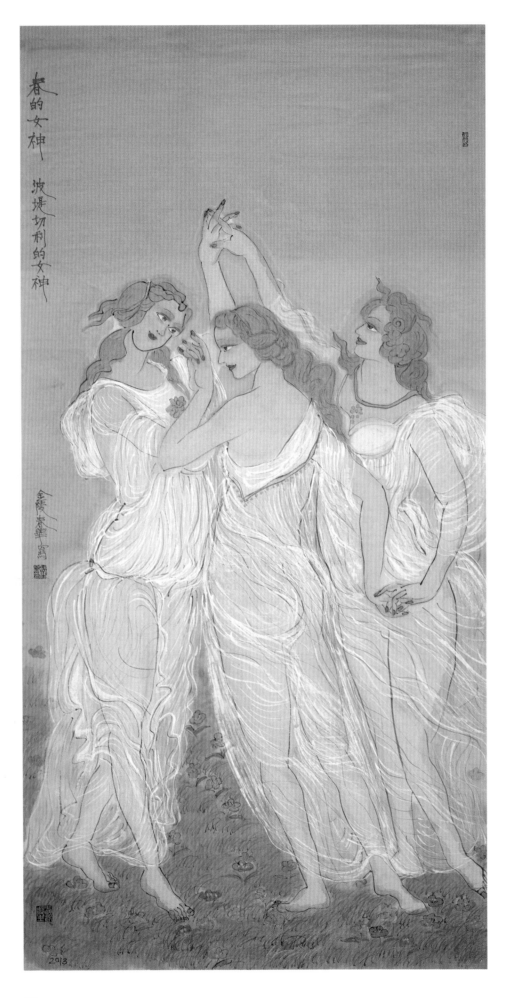

07 春的女神·波堤切利的女神

Goddess of Spring·Goddess of Botticelli

2013年
设色纸本
137cm×69.5cm

■ 款识
春的女神·波堤切利的女神，金陵春华写。
2013。

■ 钤印
春华画印（阳文）好颜色（阳文）春老花生（阴文）

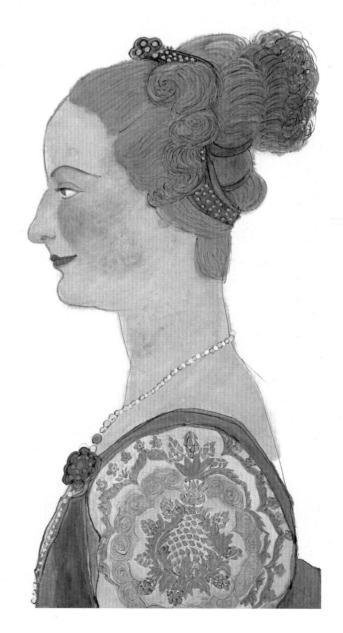

08 皮耶罗的经典

Piero's Classic

2013年
设色纸本
137cm × 70cm

■ 款识
皮耶罗的经典，金陵春华写。2013。
■ 钤印
春华画印（阳文）好颜色（阳文）春
老花生（阴文）

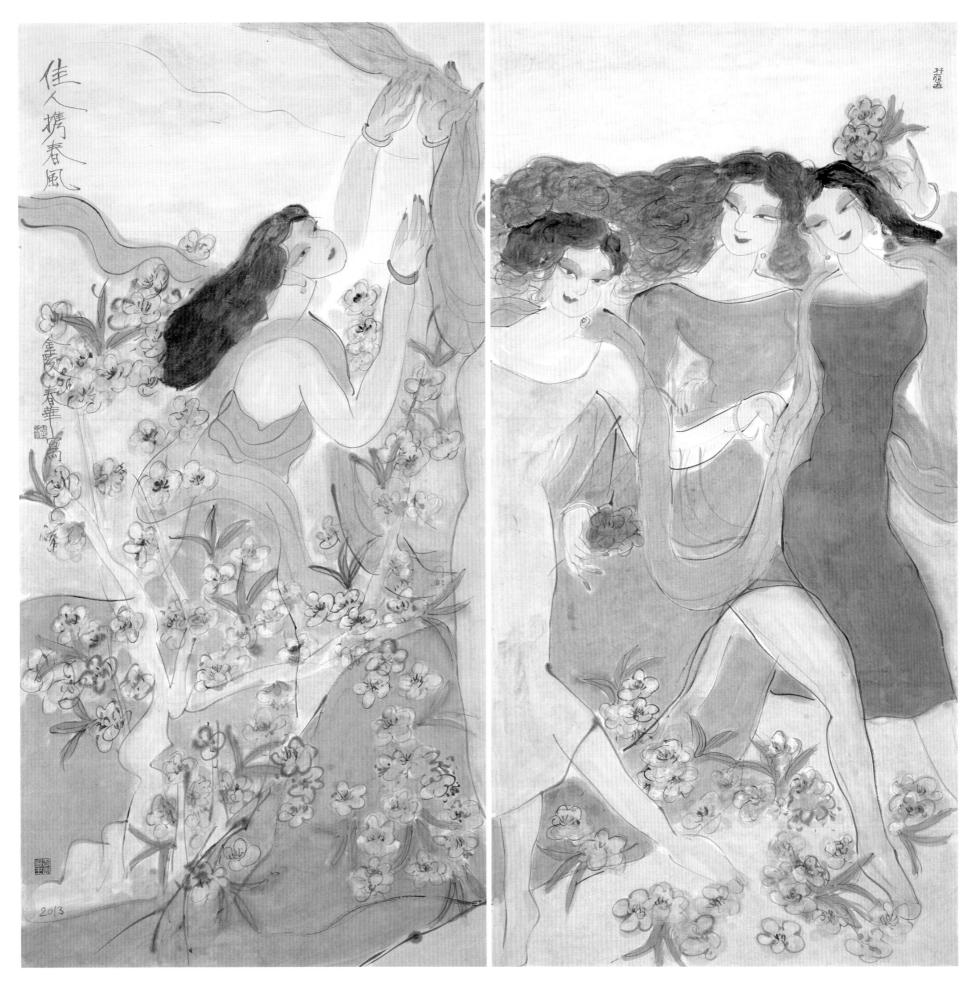

09 佳人携春风

Beauty with the Spring Breeze

2013年
设色纸本
137cm×69cm×2

■ 款识
佳人携春风，金陵春华写。2013。
■ 钤印
春华画印（阳文）好颜色（阳文）
春老花生（阴文）

胡宁娜

1958年生于江苏南京。1978年考入江苏省国画院学员班，1982年毕业，留本院人物画研究所，2001年结业于南京艺术学院研究生课程班。现为中国美术家协会会员，国家一级美术师，江苏省国画院副院长，江苏省美术家协会副主席。

Hu Ningna

Ms. Hu was born in Nanjing in 1958. She entered Jiangsu Chinese Painting Institute in 1978 and, upon graduation in 1982, stayed in the figure painting research centre of the institute. She finished her postgraduate course of Nanjing Arts Institute in 2001. Now she is a member of China Artists Association, and a national Class A artist, and the vice dean of Jiangsu Chinese Painting Academy.

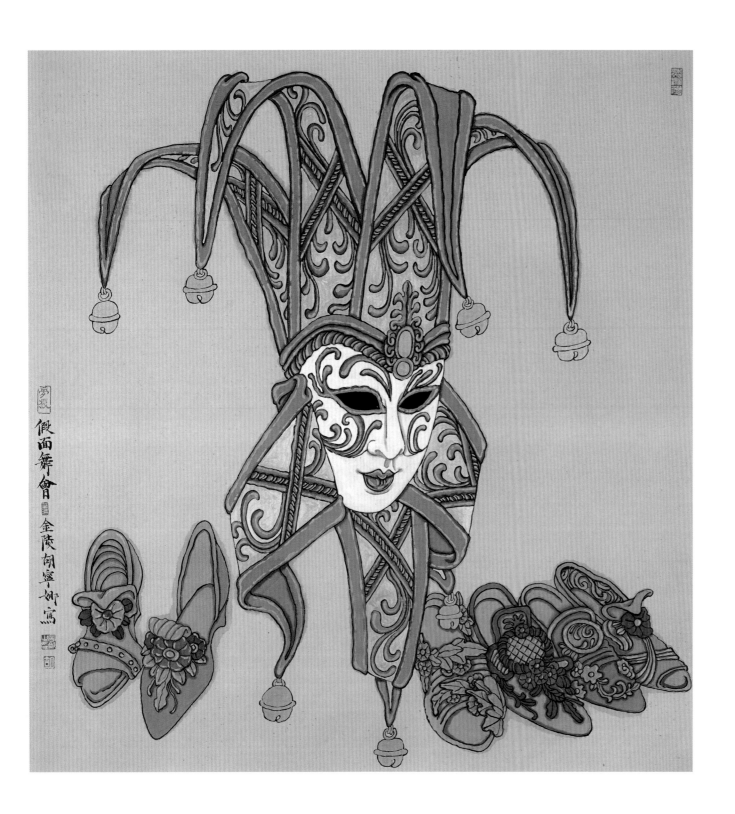

■ 01 假面舞会·7个铃铛
Masquerade·Seven Bells

2013年
设色纸本
92.5cm×88cm

■ 款识
假面舞会，金陵胡宁娜写。
■ 钤印
临窗听风观雨（阴文）梦痕（阳文）花满（阴文）宁娜之印（阴文）胡（阴文）

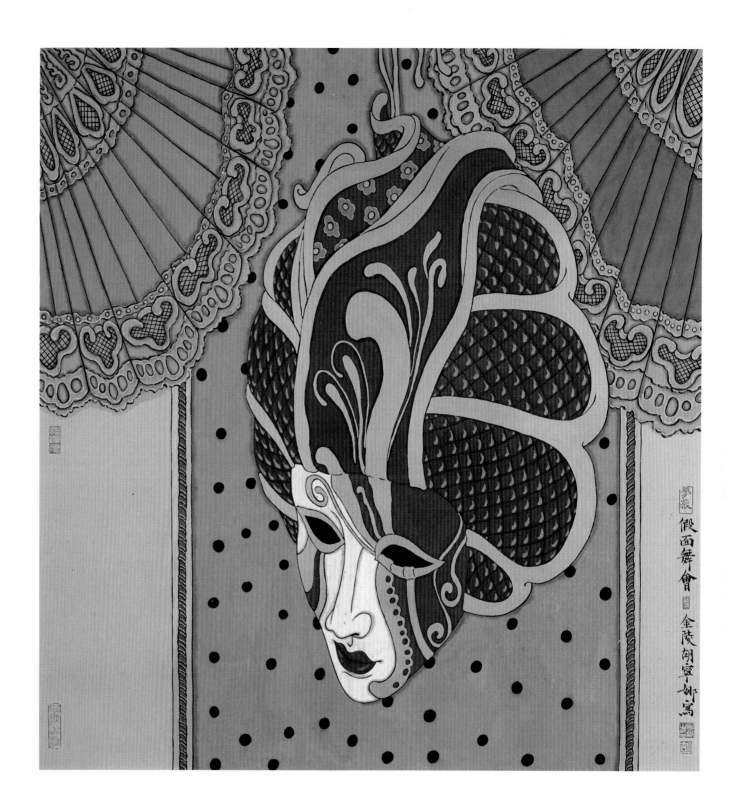

02 假面舞会·红帽子
Masquerade·Red Hat

2013年
设色纸本
93cm×88cm

■ 款识
假面舞会，金陵胡宁娜写。

■ 钤印
梦痕（阳文）花满（阴文）宁娜之印
（阴文）胡（阴文）临窗听风观雨（阴
文）风泱泱水悠悠（阳文）

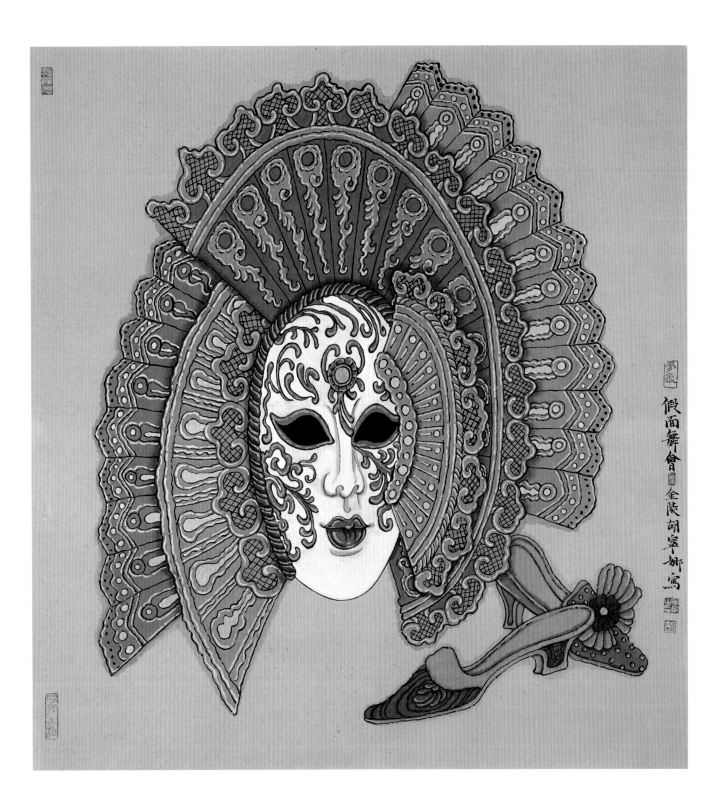

■ 03 假面舞会·鞋子、兰
帽子

Masquerade•Shoes, blue hat

2013年
设色纸本
93cm × 86cm

■ 款识
假面舞会，金陵胡宁娜写。
■ 钤印
梦痕（阳文）花满（阴文）宁娜之印
（阴文）胡（阴文）临窗听风观雨
（阴文）风泱泱水悠悠（阳文）

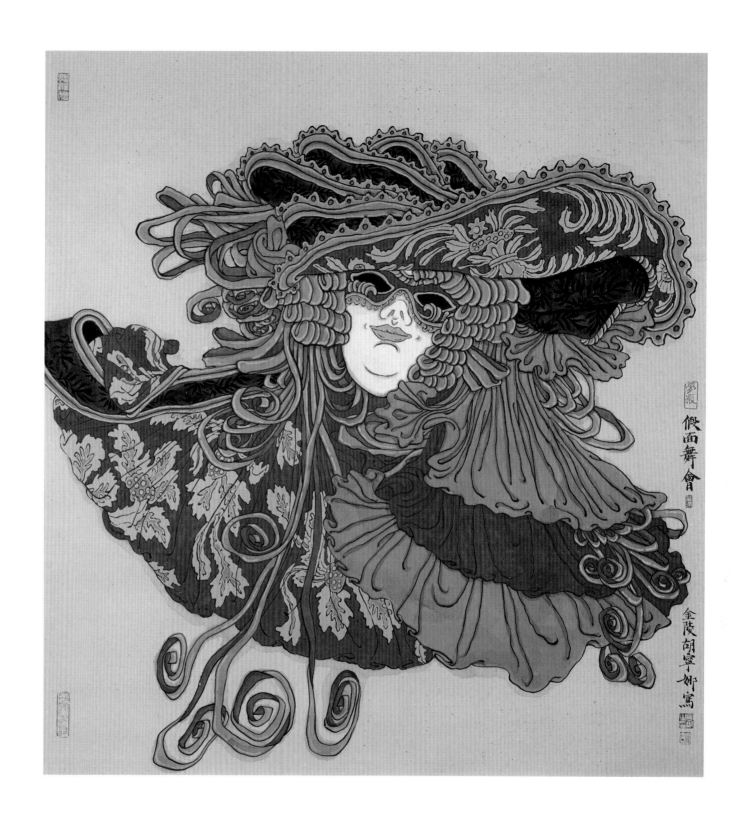

04 假面舞会·贵妇人
Masquerade·Dame

2013年
设色纸本
93cm×87.5 cm

■ 款识
假面舞会，金陵胡宁娜写。
■ 钤印
梦痕（阳文）花满（阴文）宁娜之印
（阴文）胡（阴文）临窗听风观雨（阴
文）风泱泱水悠悠（阳文）

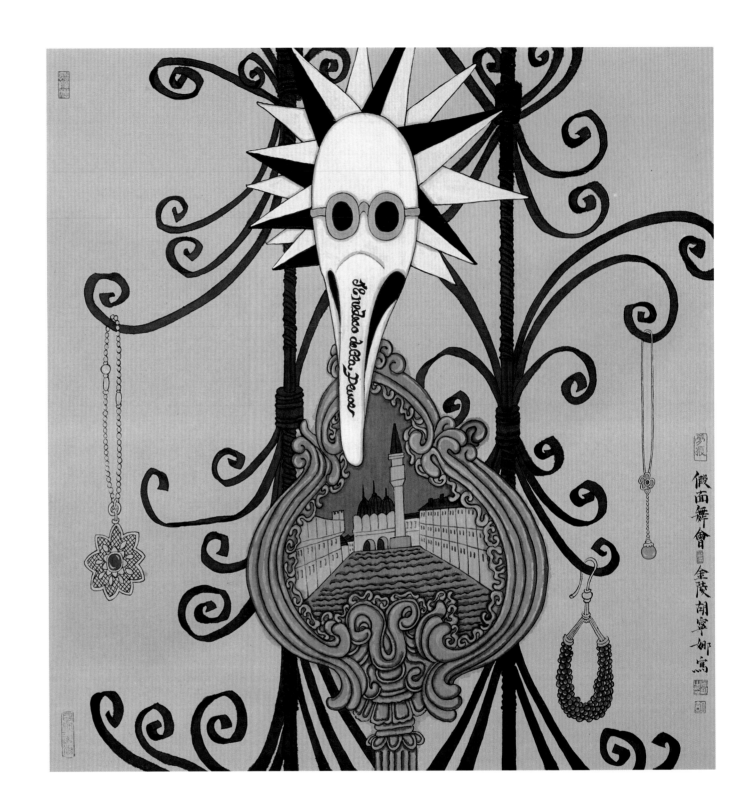

■ 06 假面舞会·魔镜

Masquerade•Mirror

2013年
设色纸本
93cm×87.5cm

■ 款识
假面舞会，金陵胡宁娜写。

■ 钤印
梦痕（阳文）花满（阴文）宁娜之印
（阴文）胡（阴文）临窗听风观雨
（阴文）风泱泱水悠悠（阳文）

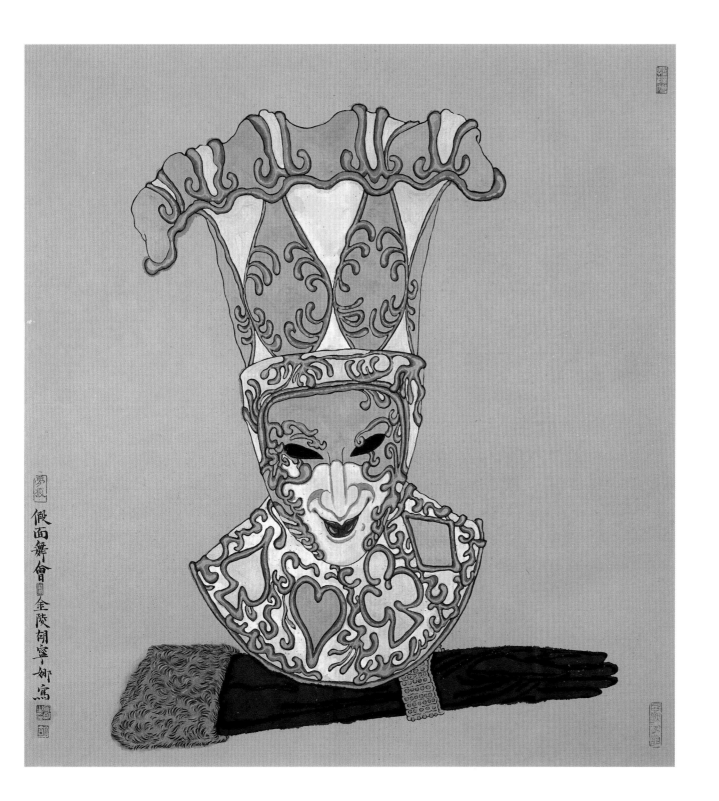

■ 07 假面舞会·手套

Masquerade·Gloves

2013年
设色纸本
93cm×86.5cm

■ 款识
假面舞会，金陵胡宁娜写。
■ 钤印
梦痕（阳文）花满（阴文）宁娜之印
（阴文）胡（阴文）临窗听风观雨
（阴文）风泱泱水悠悠（阳文）

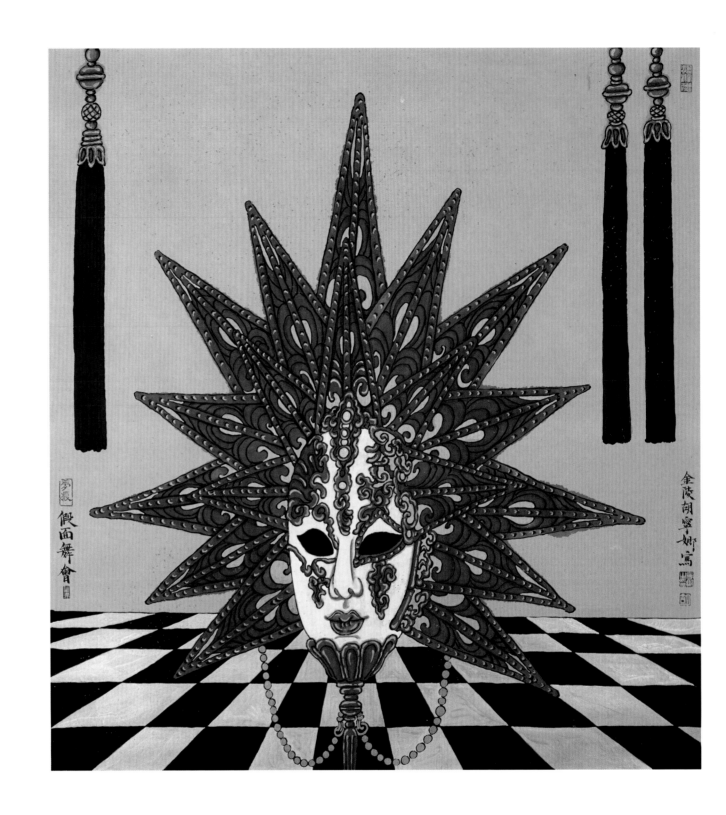

08 假面舞会·18角帽子

Masquerade·18 Corner Hat

2013年
设色纸本
93cm×86cm

■ 款识
假面舞会，金陵胡宁娜写。

■ 钤印
梦痕（阳文）花满（阴文）宁娜之印（阴文）胡（阴文）临窗听风观雨（阴文）风泱泱水悠悠（阳文）

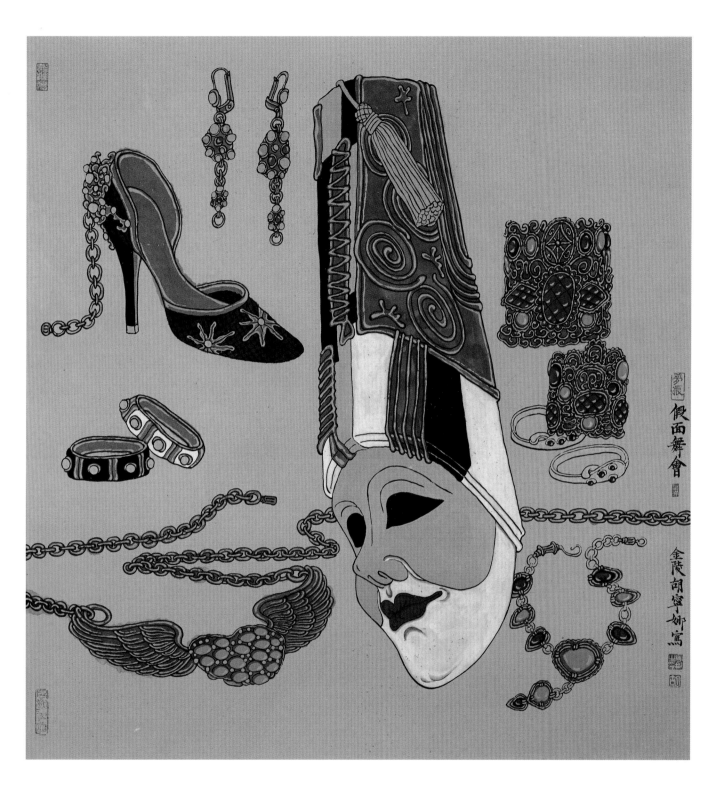

■ 09 假面舞会·高帽子

Masquerade·Tall Paper Hat

2013年
设色纸本
93cm × 87cm

■ 款识
假面舞会，金陵胡宁娜写。
■ 钤印
梦痕（阳文）花满（阴文）宁娜之印
（阴文）胡（阴文）临窗听风观雨
（阴文）风泱泱水悠悠（阳文）

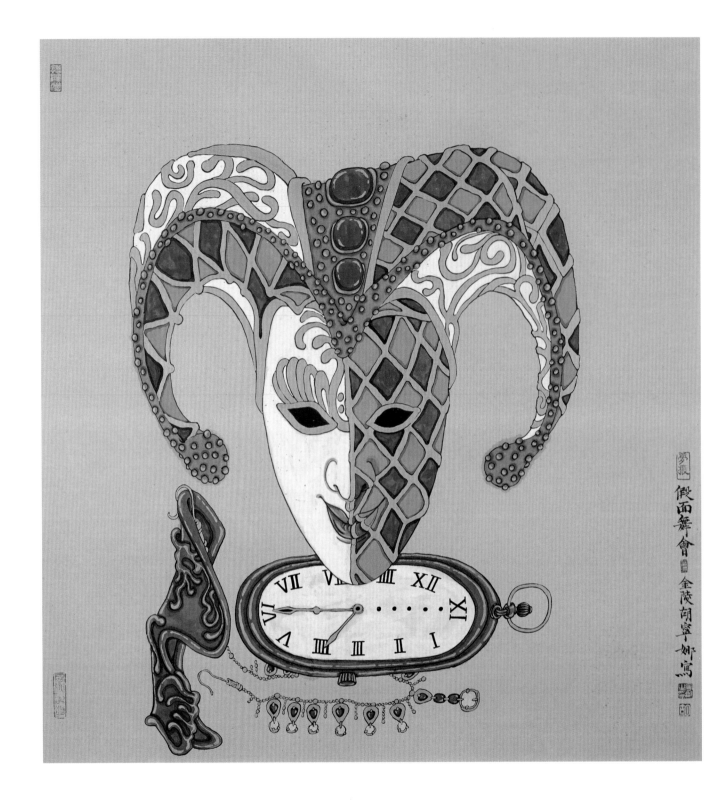

10 假面舞会·罗马钟

Masquerade·Rome Bell

2013年
设色纸本
93cm×87.5cm

■ 款识
假面舞会，金陵胡宁娜写。

■ 钤印
梦痕（阳文）花满（阴文）宁娜之印（阴文）胡（阴文）临窗听风观雨（阴文）风泱泱水悠悠（阳文）

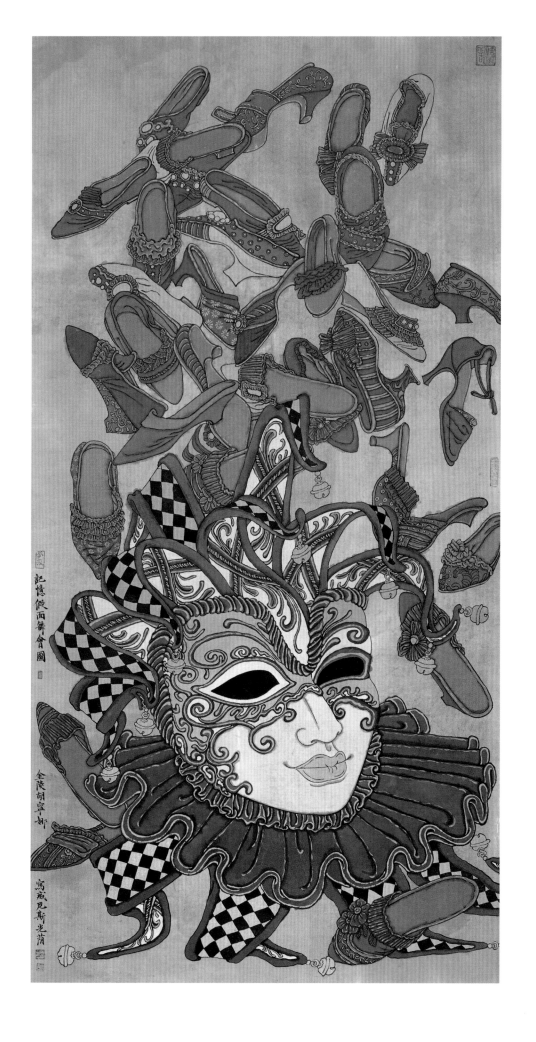

11 记忆假面舞会图

Image of Masquerade in Memory

2013年
设色纸本
191.5cm × 97.5cm

■ 款识
记忆假面舞会图。金陵胡宁娜写威尼斯光阴。

■ 钤印
梦痕（阳文）花满（阴文）宁娜之印（阴文）胡（阴文）听风阁（阳文）风泱泱水悠悠（阳文）

聂危谷

1957年生于江苏扬州。1981年毕业于南京师范大学美术学院；1988年毕业于中国艺术研究院，1998年毕业于南京艺术学院，分别获美术学学士、硕士、博士学位。现任南京大学美术研究院副院长、教授、硕士生导师，兼任南京博物院特邀研究员，曾任扬州大学艺术学院院长。

Nie Weigu

Mr. Nie was born in Yangzhou, Jiangsu in 1957. He graduated from the School of Fine Arts, Nanjing Normal University in 1981, from China Art Academy in 1988, and Nanjing Arts Institute in 1998, and got BA, MA and PhD degrees respectively. Now he is the vice-President and a professor and M.A. supervisor of the Academy of Fine Arts, Nanjing University. He is also a specially invited researcher in Nanjing Museum. He once served as dean of the School of Fine Arts, Yangzhou University.

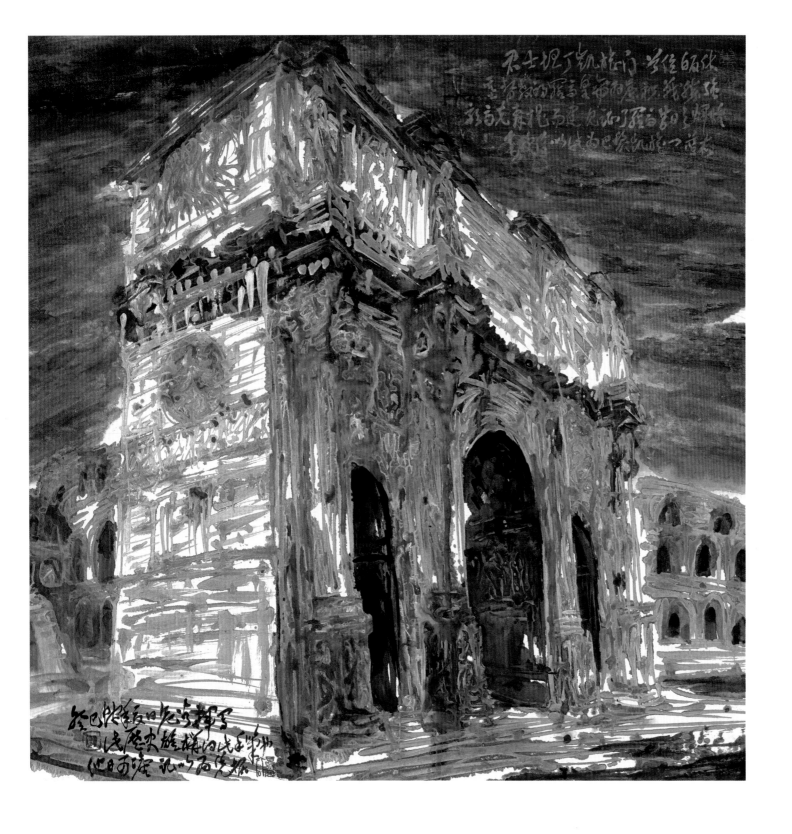

■ 01 君士坦丁凯旋门

Arch of Constantine

2013年
设色纸本
69.5cm × 69cm

■ 款识
君士坦丁凯旋门。首位皈依基督教的罗马皇帝为庆祝战胜强敌马克森提而建，见证了罗马昔日之辉煌，拿破仑以此为巴黎凯旋门蓝本。
癸巳蛇年夏日，危谷挥写此历史雄构的大手笔也。他日可鉴记以为凭据。

■ 钤印
坐禅肖形印（阴文）聂危谷（阴文）羽霄阁（阳文）

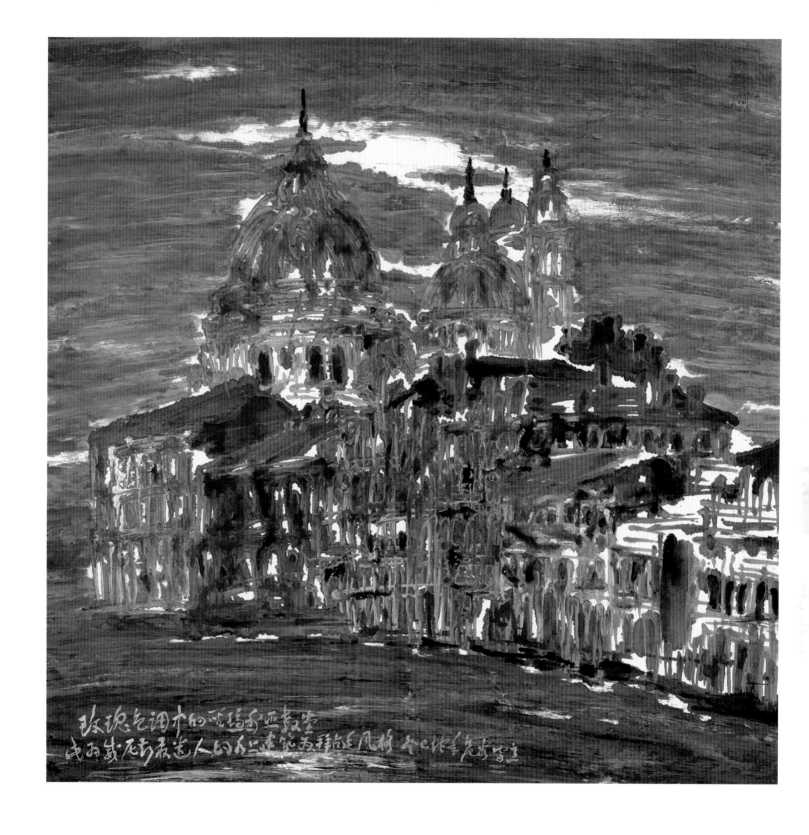

■ 02 玫瑰色调中的圣玛利亚教堂

The Church of St in Rose Color

2013年
设色纸本
69cm×69.5cm

■ 款识
玫瑰色调中的圣玛利亚教堂。此为威尼斯最迷人的水上
建筑，为拜占庭风格。癸巳蛇年，危谷写意。
■ 钤印
聂危谷（阳文）彩晕墨章（阳文）羽霄阁（阳文）

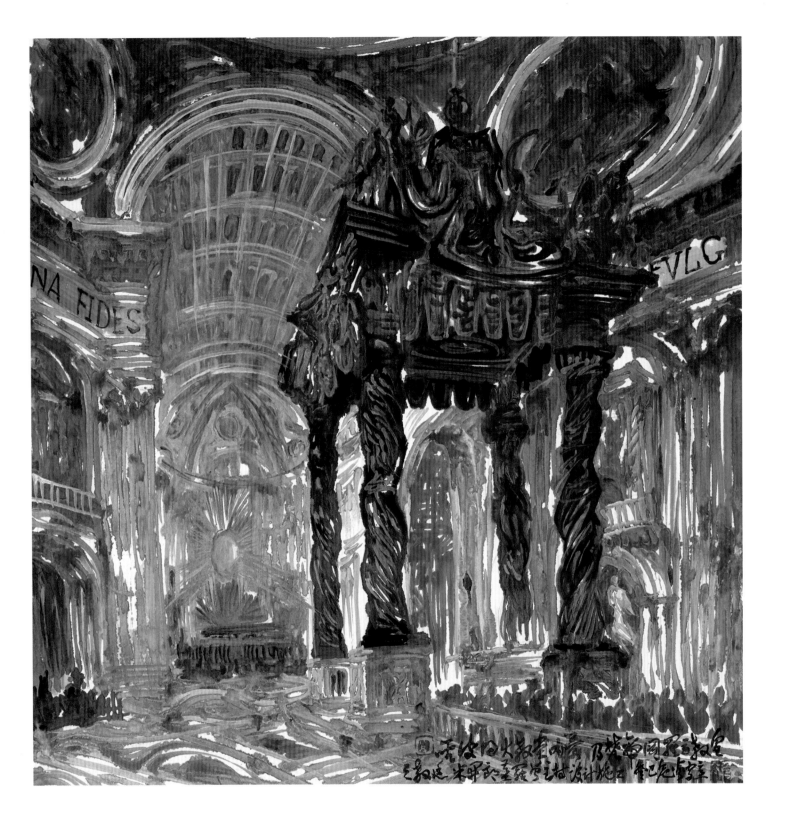

St Peter's Interior

2013年
设色纸本
69.5cm × 68cm

■ 款识
圣彼得大教堂内景，乃梵蒂冈罗马教皇之教廷，米
开朗基罗曾主持设计施工。癸巳危谷写意。
■ 钤印
坐禅肖形印（阴文）危谷（阴文）羽霄阁（阳文）

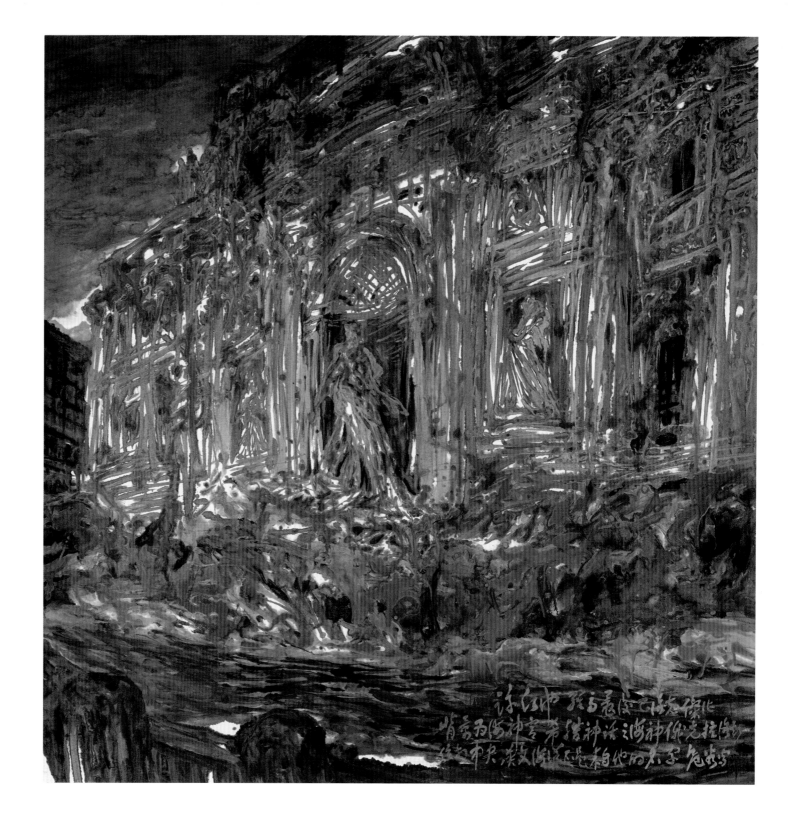

■ 04 许愿池

Trevi Fountain

2013年
设色纸本
89cm × 98cm

■ 款识
许愿池。罗马最后巴洛克杰作，背景为海神宫，希腊
神话之海神俄克拉洛斯位于中央，英文海洋正是来自
他的名字。危谷写。

■ 铃印
羽胄阁（阳文）坐禅肖形印（阴文）聂危谷（阳文）

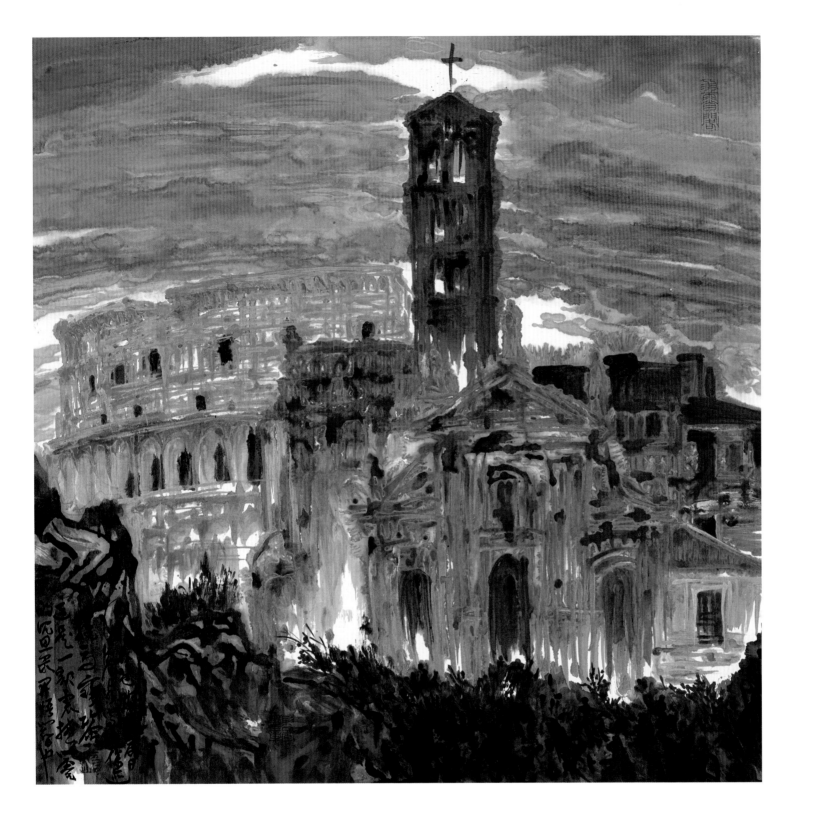

■ 05 罗马宝鉴

Roman Treasures

2013年
设色纸本
69cm × 69.5cm

■ 款识
罗马宝鉴。这是一部震撼心灵的沉思录，开悟心
智也。癸巳蛇年夏日，危谷写此伟迹。

■ 钤印
危谷（阴文）羽霄阁（阳文）彩晕墨章（阳文）

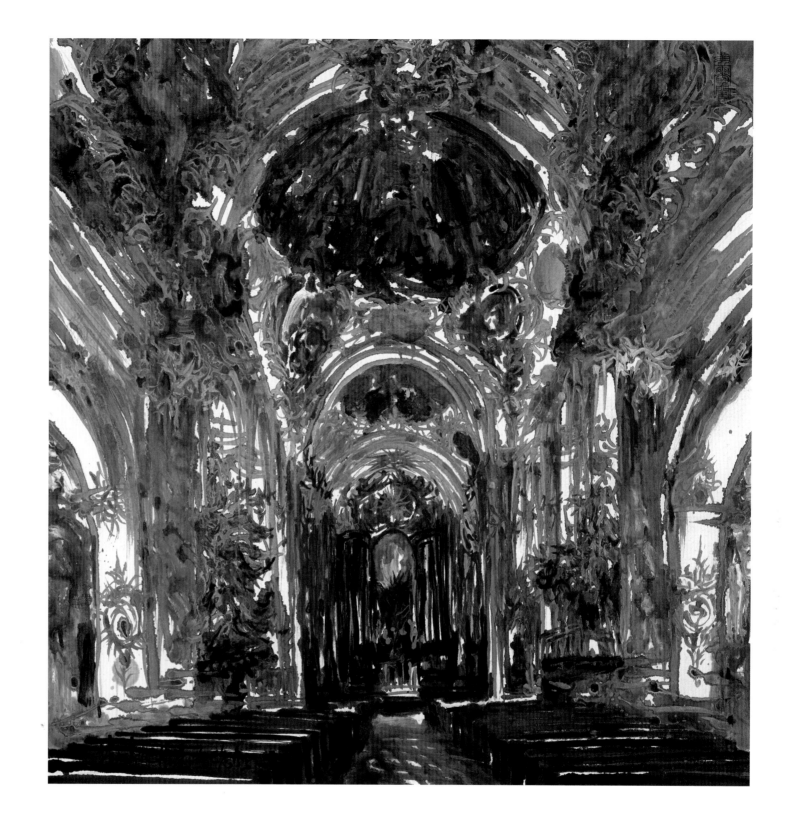

■ 06 共鸣巴洛克

Struck a Chord with Baroque

2013年
设色纸本
69.5cm×68cm

■ 款识
共鸣巴洛克，癸巳危谷写。
■ 钤印
聂危谷（阳文）羽霄阁（阳文）

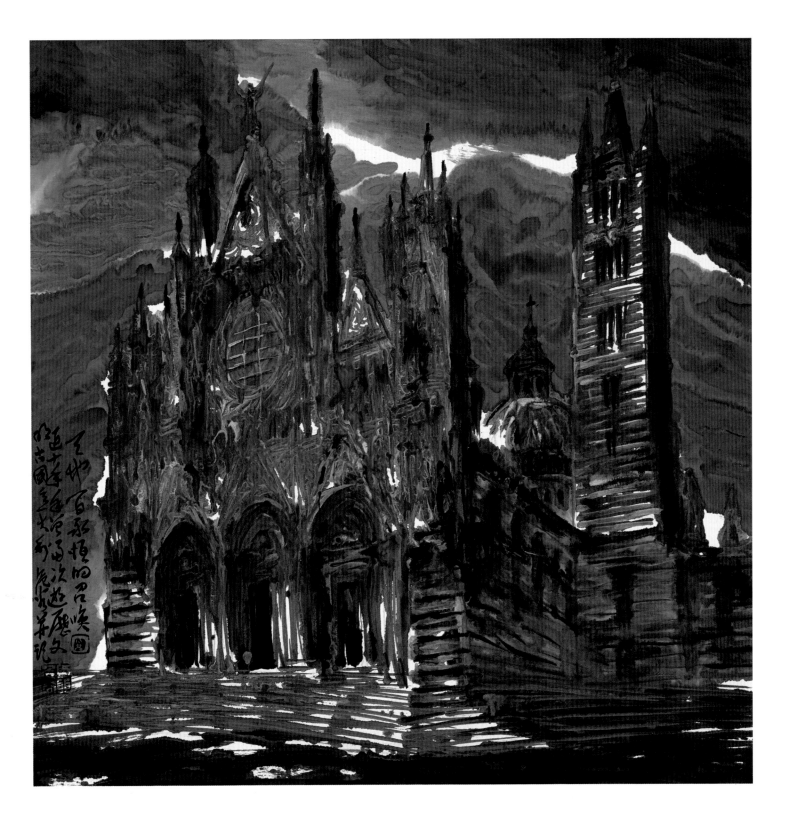

07 天地间永恒的召唤

Summon between Heaven and Earth

2013年
设色纸本
69.5cm × 69cm

■ 款识
天地间永恒的召唤。近十年余曾多次
游历文明古国意大利。危谷并记。
■ 钤印
坐禅肖形印（阴文）聂危谷（阴文）
羽霄阁（阳文）

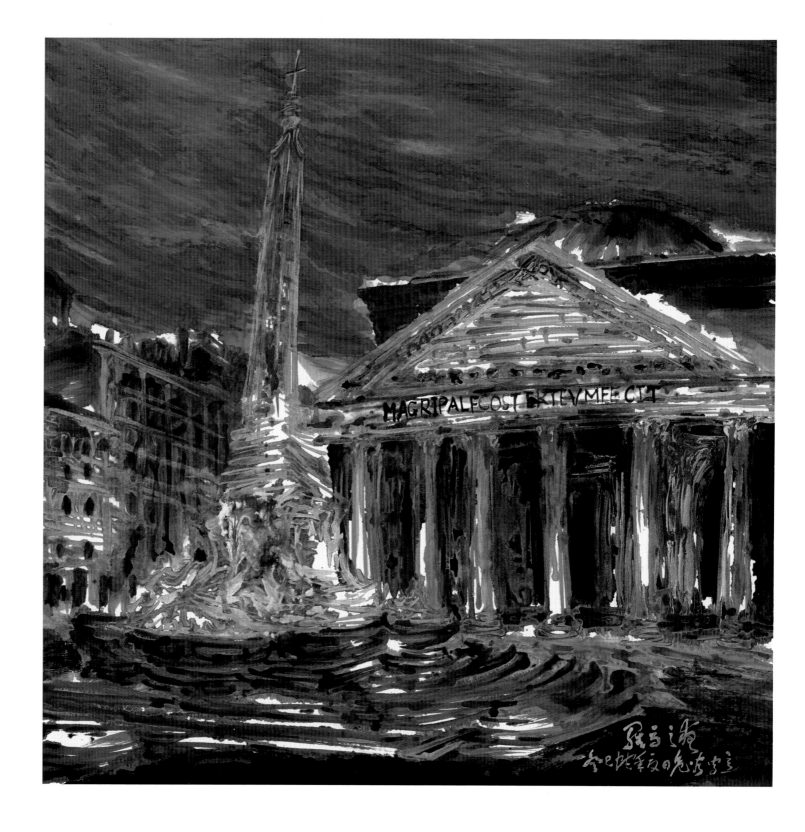

■ 08 罗马之夜

Roman Nights

2013年

设色纸本

69cm × 69.5cm

■ 款识

罗马之夜。癸巳蛇年夏日，危谷写意。

■ 钤印

危谷（阴文）羽霄阁（阳文）彩晕墨章

（阳文）

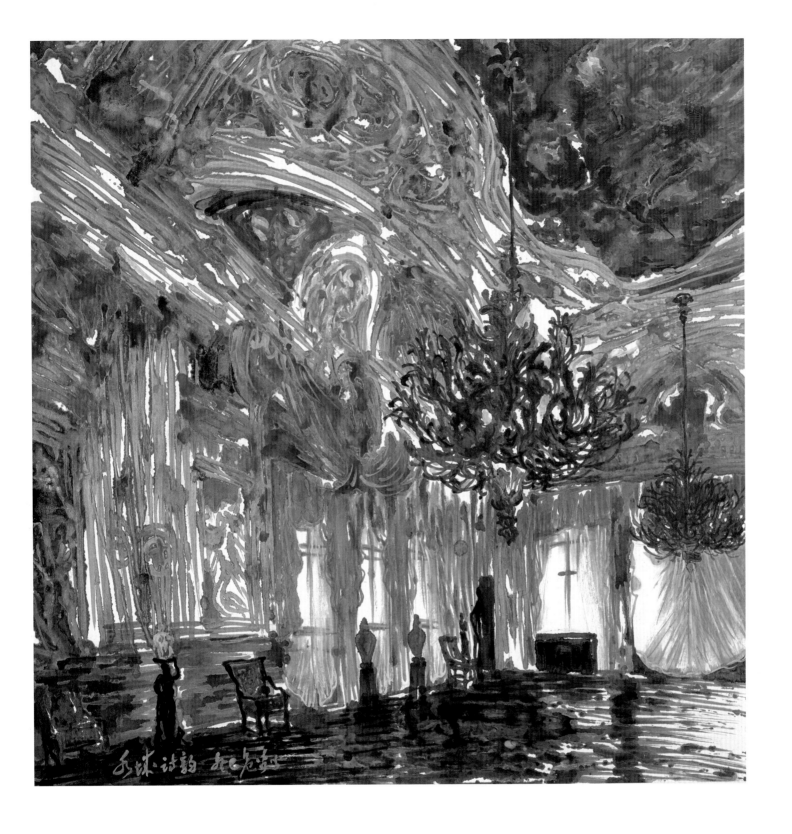

■ 09 水域诗韵

Waters of Poetry

2013年
设色纸本
69.5cm×68cm

■ 款识
水域诗韵，癸巳危谷写。
■ 钤印
羽霄阁（阳文）笔走龙蛇（阳文）聂危谷（阳文）

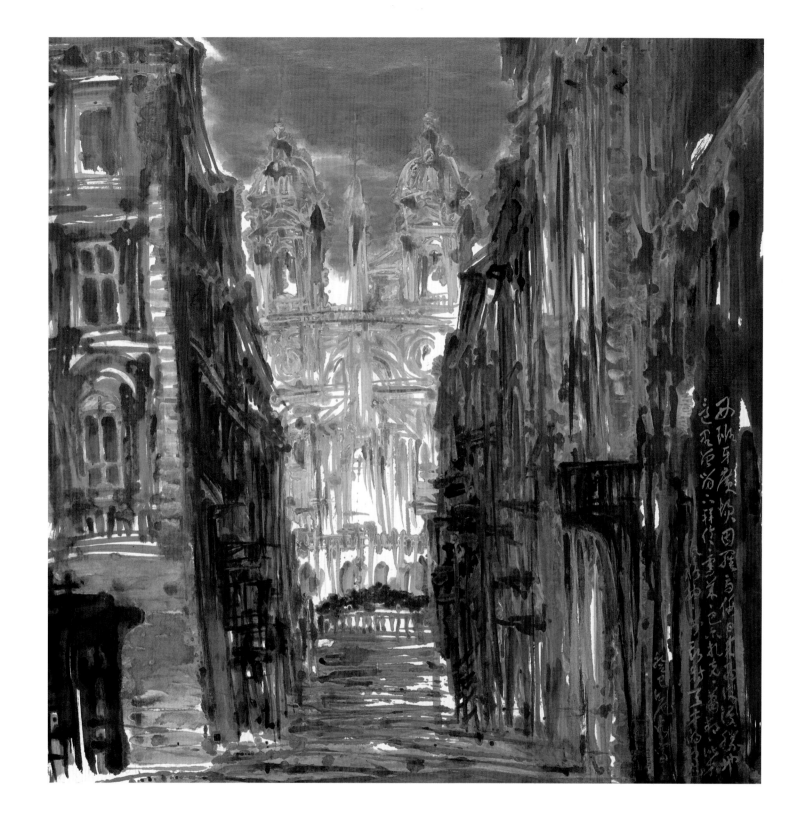

10 西班牙广场

The Spanish Square

2013年

设色纸本

69.5cm × 69cm

西班牙广场因《罗马假日》成为浪漫圣地，这里曾留下
拜伦、雪莱、巴尔扎克、肖邦、瓦格纳、李斯特天才的
印迹。癸巳危谷写。

■ 钤印

坐禅肖形印（阴文）聂危谷（阴文）彩晕墨章（阳文）

徐乐乐

1955年6月生于江苏南京。1976年毕业于南京艺术学院美术系，1978年进江苏省国画院至今。中国美术家协会会员，国家一级美术师。

Xu Lele

Mrs. Xu was born in Nanjing in June, 1955. She graduated from the Department of Fine Art of Nanjing Arts Institute. She has been working in Jiangsu Academy of Chinese Painting since 1978. She is a member of China Artists Association and a national Class A artist.

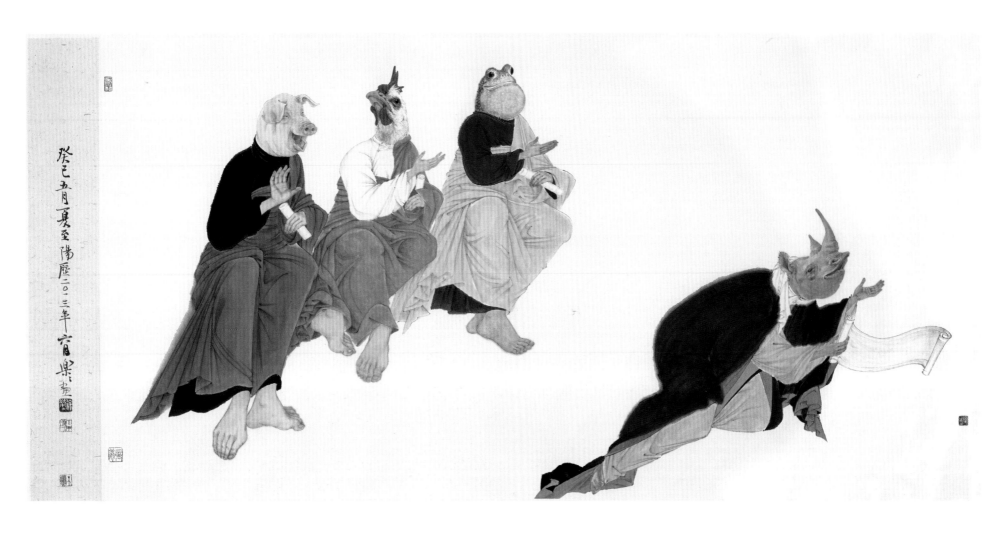

 02 肖像集卷二之二

Portrait Collection Volume 2 # 2

2013年
设色纸本
97.5cm × 60.5cm

■ 钤印

长乐（阴文）暝琴处（阴文）乐乐书屋
（阳文）水清石出（阳文）

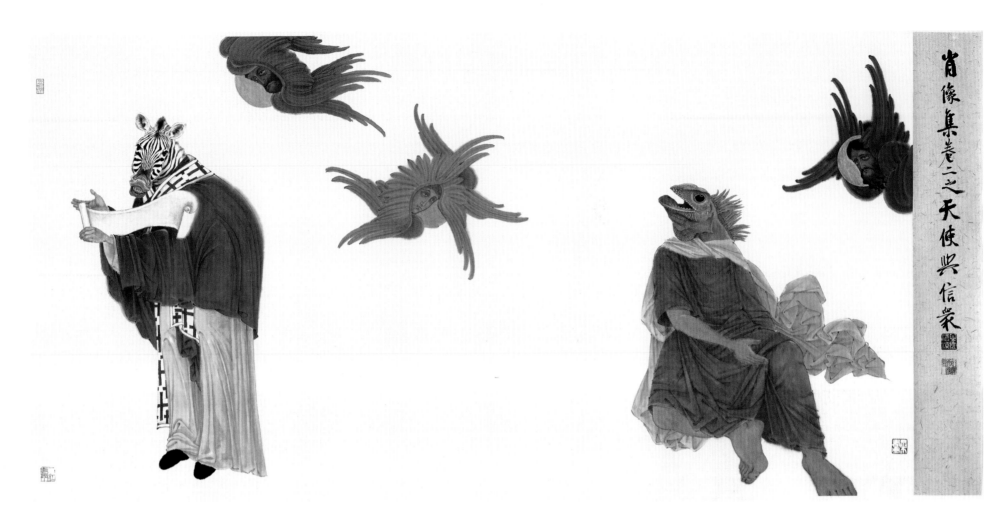

■ 03 肖像集卷二之三
Portrait Collection Volume 2 # 3

2013年
设色纸本
70cm×136cm

■ 款识
肖像集卷二之天使与信众。
■ 钤印
心地清凉（阴文）思阐斋秘笈（阳文）
乐乐画（阴文）月淡（阴文）一江花雨
（阳文）

忏悔中之玛德莱娜。癸巳初夏乐乐尝试写意拉图尔于乐乐书屋

04 忏悔中之玛德莱娜

Madeline Lena in the Confession

2013年
设色纸本
97.5cm×45.5cm

■ 款识
忏悔中之玛德莱娜。癸巳初夏，乐乐尝试写意拉图尔
于乐乐书屋。

■ 钤印
乐乐之印（阴文）徐（阴文）梦水回云（阴文）月淡
（阴文）乐乐书屋（阳文）

05 圣马可祈祷图

Image of St. Mark's Prayer

2013年
设色纸本
97.5cm×45.5cm

■ 款识
圣马可祈祷图。癸巳初夏，乐乐画。

■ 钤印
乐乐之印（阴文）徐（阴文）水清石出（阳文）
一老翁（阴文）大本领人（阳文）四榕寺灵泉
（阴文）

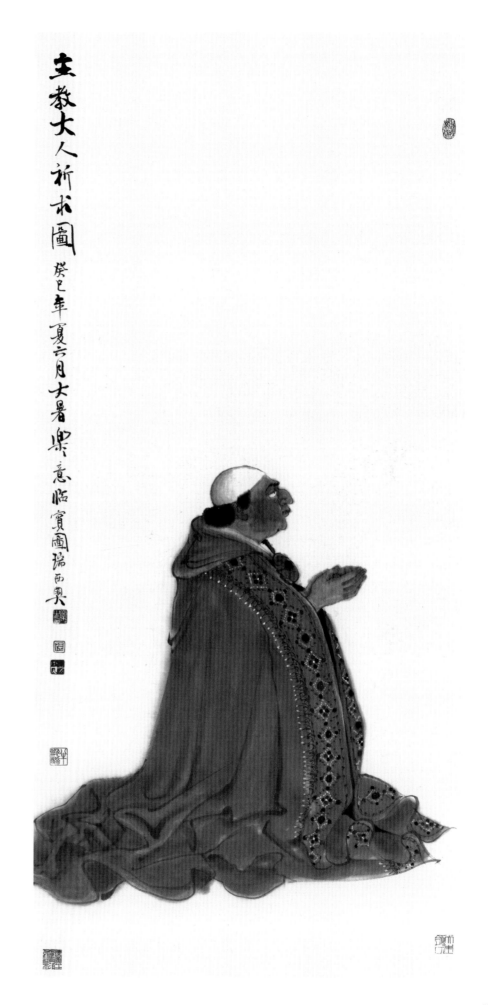

06 主教大人祈求图

Image of Bishop's Prayer

2013年
设色纸本
97.5cm×45cm

■ 款识
主教大人祈求图。癸巳年夏六月大暑，乐乐意临宾图瑞西奥。

■ 钤印
乐乐之印（阴文）徐（阴文）不贪（阴文）半瓶醋（阳文）
要图生富贵须下死工夫（阳文）欲采芙蓉（阳文）大本领人
（阳文）

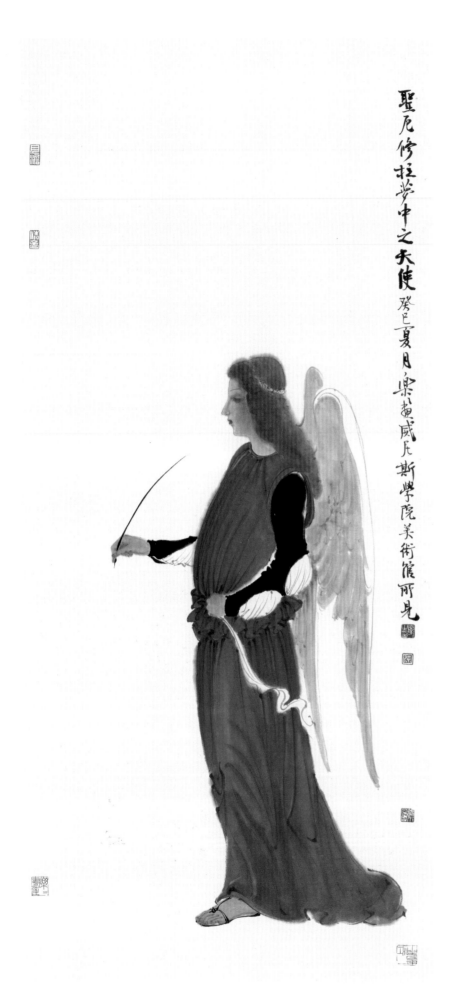

聖厄修拉夢中之天使 癸巳夏月，樂樂畫威尼斯學院美術館所見

07 圣厄修拉梦中之天使

The Urban Seurat Dream of an Angel

2013年
设色纸本
97.5cm×45.5cm

■ 款识
圣厄修拉梦中之天使。癸巳夏月，乐乐画威尼斯
学院美术馆所见。

■ 钤印
乐乐之印（阴文）徐（阴文）梦水回云（阴文）
一江花雨（阳文）月淡（阴文）清音（阴文）

常进

1951年生于江苏省南京市。1978年考入江苏省国画院学员班，1982年毕业，现为江苏省国画院山水画研究所所长，中国美术家协会会员，国家一级美术师，江苏省政协委员。

Chang Jin

Mr. Chang was born in Nanjing in 1951. He began to study in Jiangsu Academy of Chinese Painting in 1978 and graduated in 1982. Now he is the director of the Landscape Painting Research Centre of Jiangsu Academy of Chinese Painting. He is a member of China Artists Association, a national Class A artist and a member of Jiangsu Committee of CPPCC.

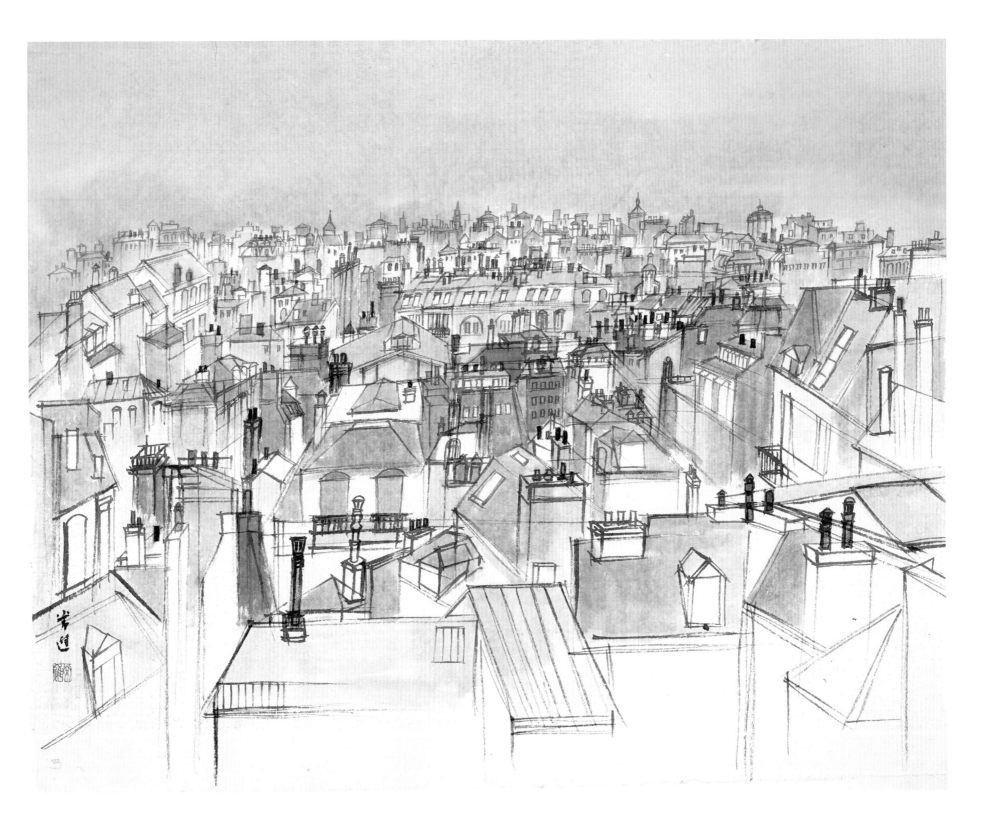

■ 01 巴黎的屋顶
Rooftops of Paris

2013年
设色纸本
77cm×98cm

■ 款识
常进

■ 钤印
常进（阳文）

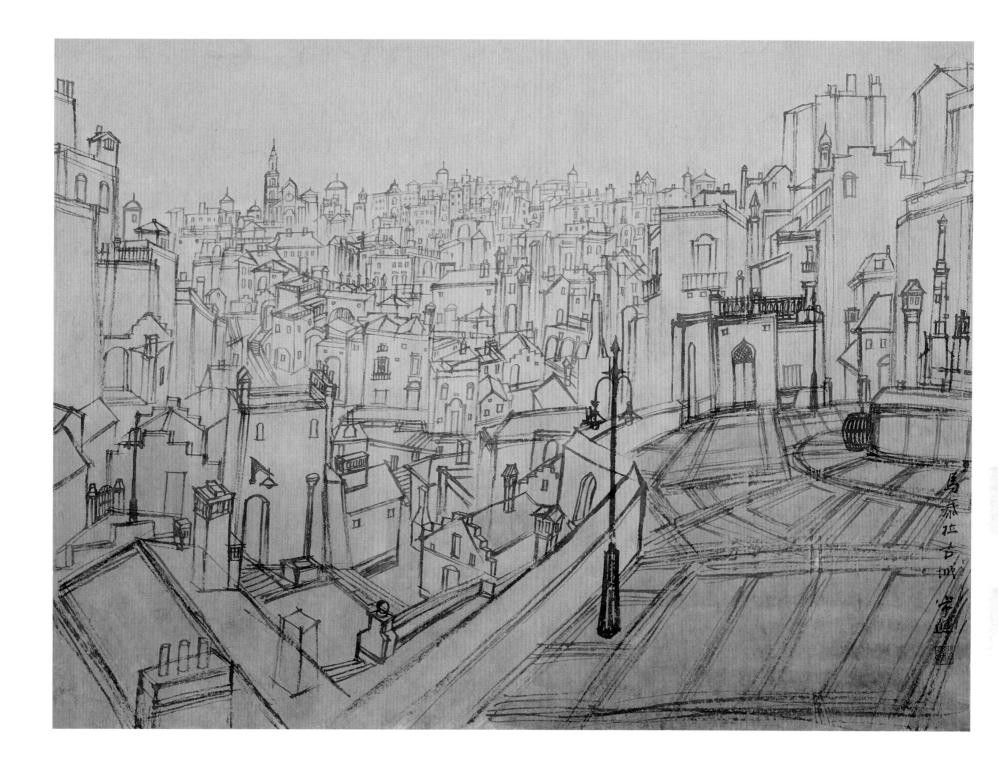

■ 02 马泰拉古城

The Ancient City of Matera

2013年
设色纸本
70cm × 95cm

■ 款识
马泰拉古城，常进。
■ 钤印
常进（阳文）

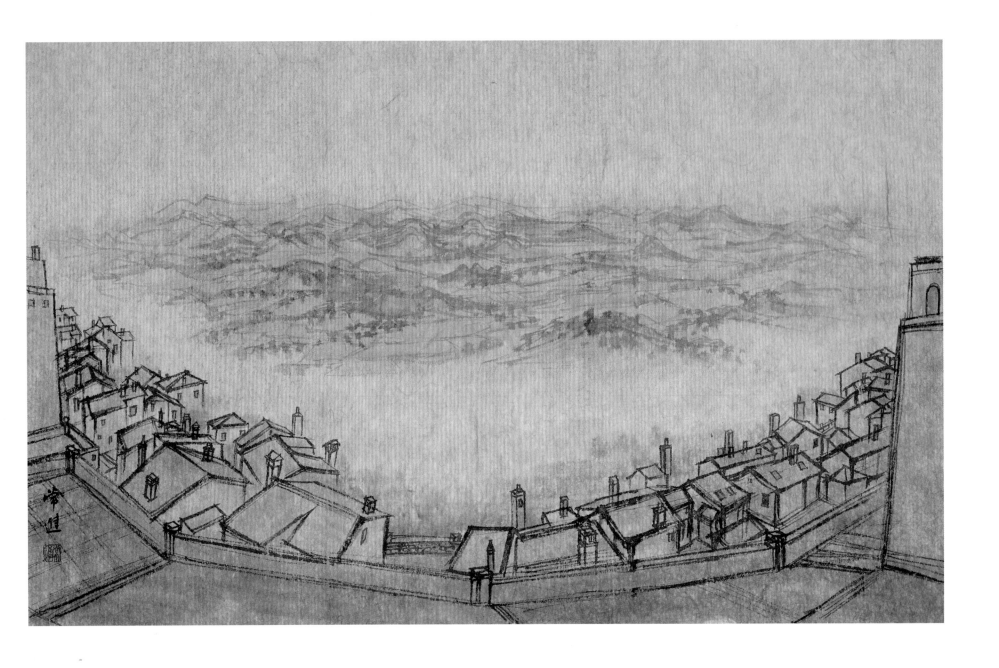

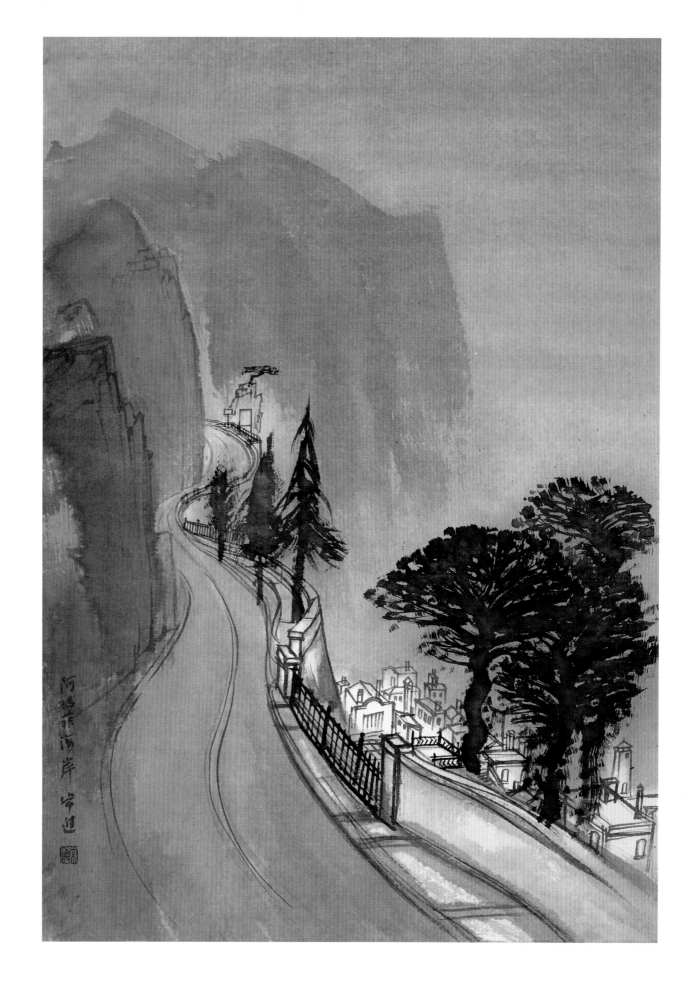

04 阿玛菲海岸（一）

Amalfi Coast Ⅰ

2013年
设色纸本
100cm×71cm
■ 款识
阿玛菲海岸，常进。
■ 钤印
常进（阳文）

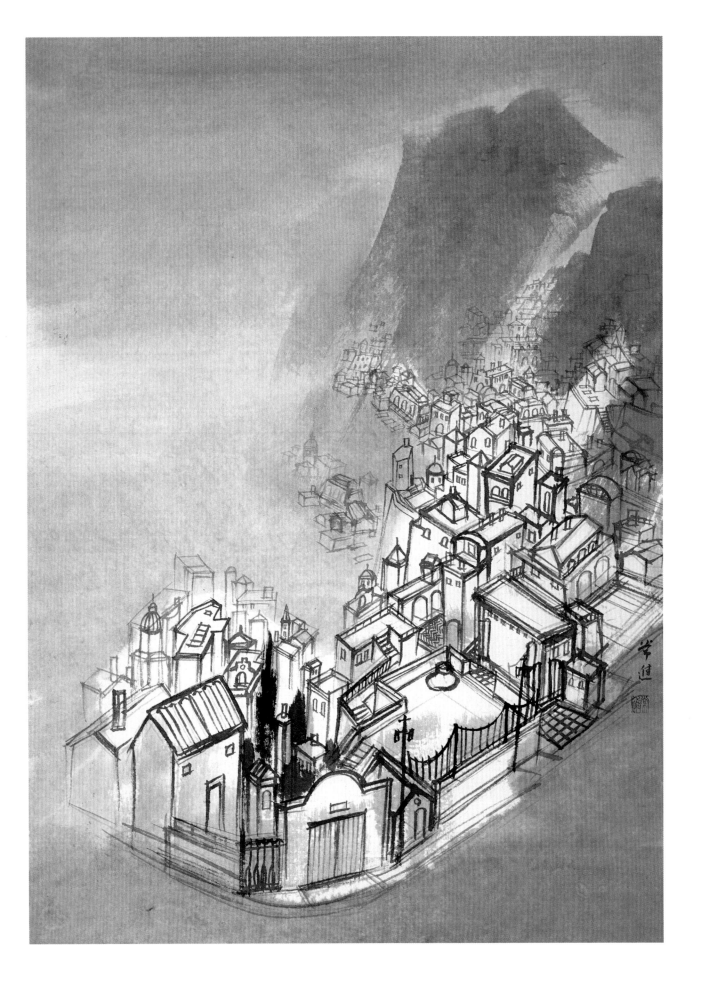

■ 05　阿玛菲海岸（二）

Amalfi Coast II

2013年
设色纸本
100cm×71cm
■ 款识
常进
■ 钤印
常进（阳文）

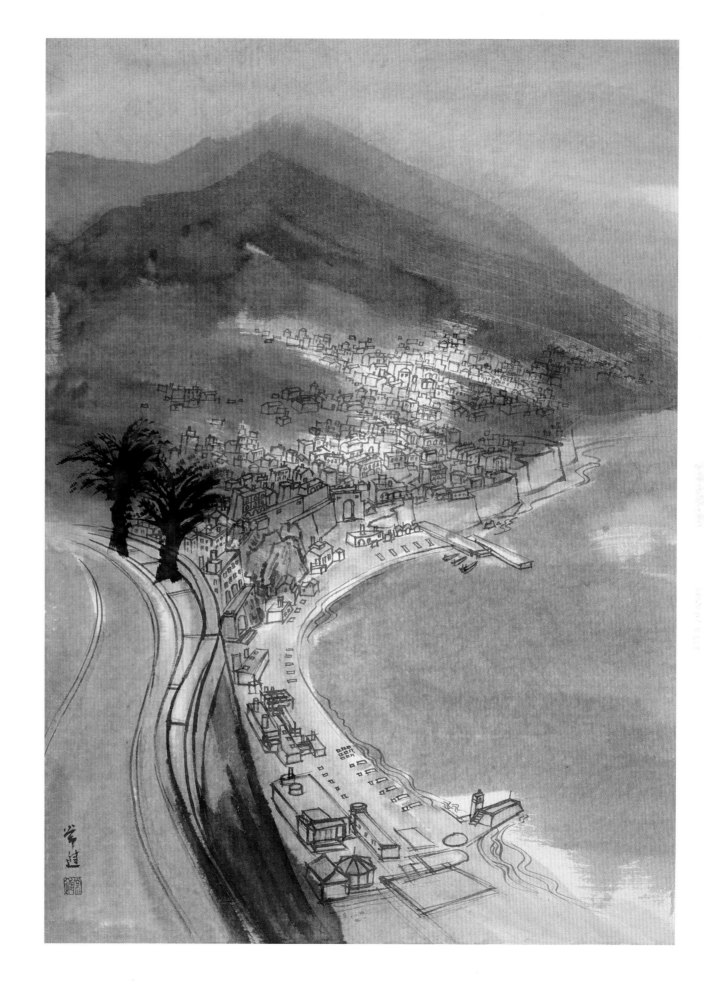

06 阿玛菲海岸（三）

Amalfi Coast III

2013年
设色纸本
100cm×71cm

■ 款识
常进

■ 钤印
常进（阳文）

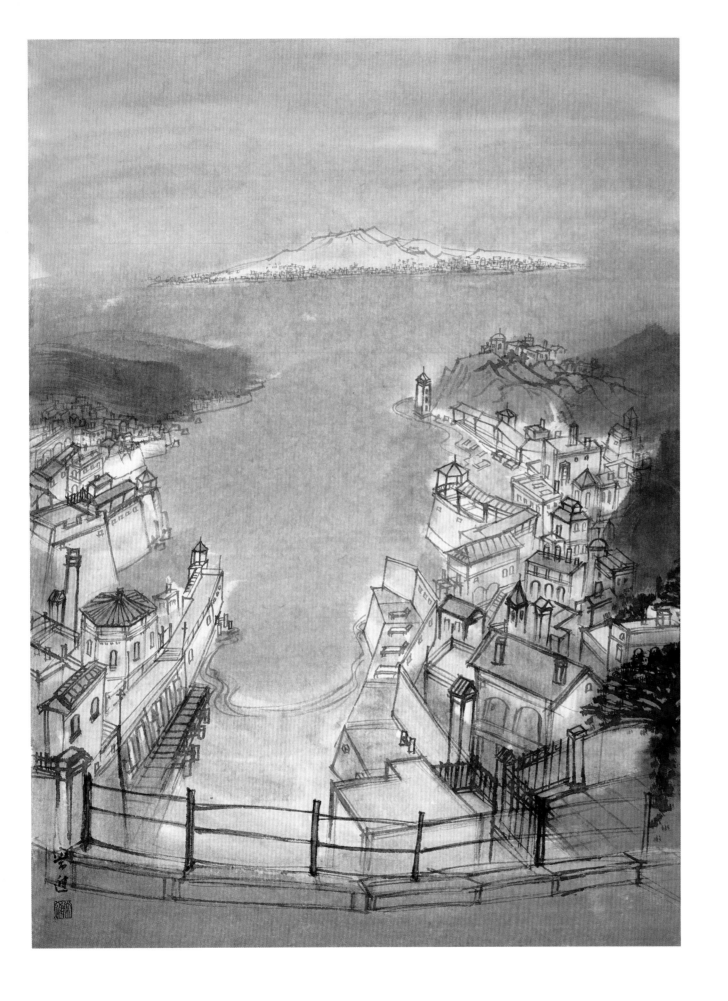

07 阿玛菲海岸（四）

Amalfi Coast Ⅳ

2013年
设色纸本
100cm×71cm

款识
常进
钤印
常进（阳文）

喻慧

1960年生于江苏南京。1980至1983年江苏省国画院专科毕业，2000至2002年南京艺术学院研究生班毕业，现为中国美术家协会会员，国家一级美术师，江苏省国画院副院长、花鸟画研究所所长。

Yu hui

Born in Nanjing in 1960. From 1980 to1983, he studied and graduated from the Jiangsu Province Guohua Academy college; from 2000 to 2002, he finished his graduate degree at the Nanjing Art Institute. Currently, he is a member of the China Artists Association, a national-level artist, and the director of the Jiangsu Province Guohua Academy's Bird-and-Flower Painting Research Institute.

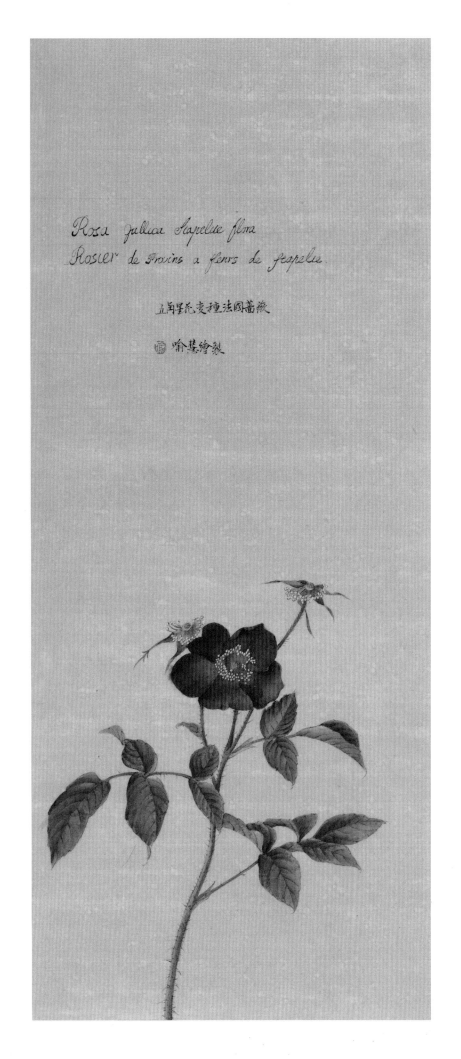

01 五角星花变种法国蔷薇

Stapelia Variant of French Rose

2013年
镜片
66cm×28cm

■ 款识
五角星花变种法国蔷薇，喻慧绘制。
■ 钤印
喻（阳文）

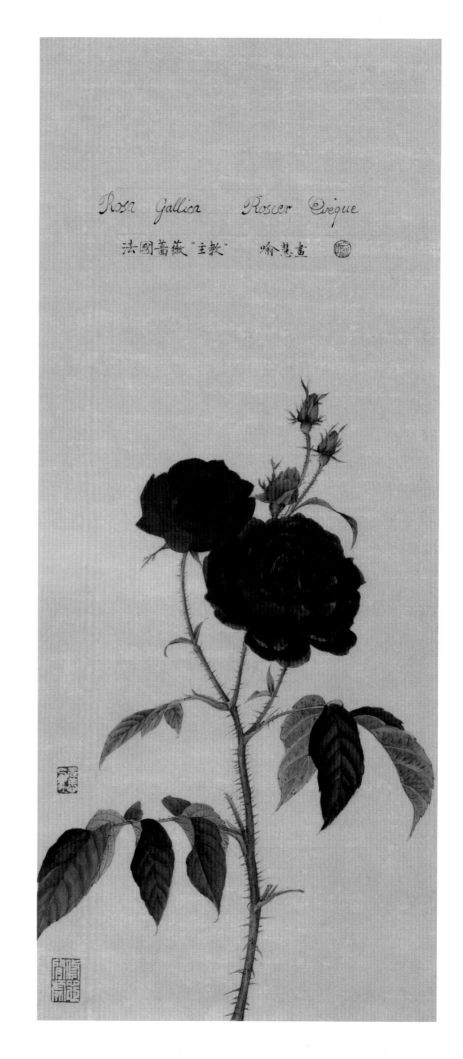

Rosa Gallica Rosier Évèque

法国蔷薇"主教" 喻慧画

02 法国蔷薇"主教"

"Bishop"-France Rose

2013年
镜片
66cm × 28cm

■ 款识
法国蔷薇"主教",喻慧画。
■ 钤印
喻(阳文)无恙鸟(阴文)修心心闲处(阴文)

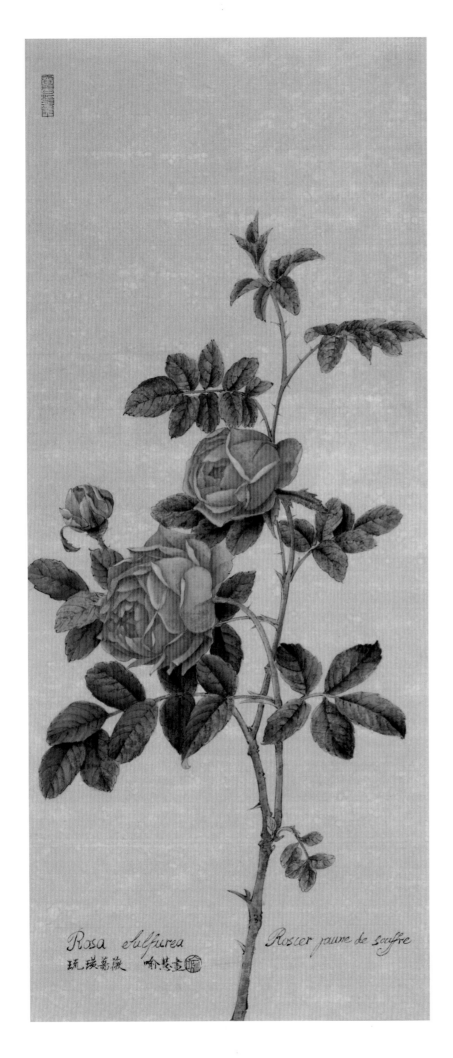

Rosa sulfurea Rosier jaune de soufre

琉璃蔷薇 喻慧画

■ 03 琉璃蔷薇
Glass Rose

2013年
镜片
66cm×28cm

■ 款识
琉璃蔷薇,喻慧画。
■ 钤印
喻(阳文)春得一江花雨(阳文)

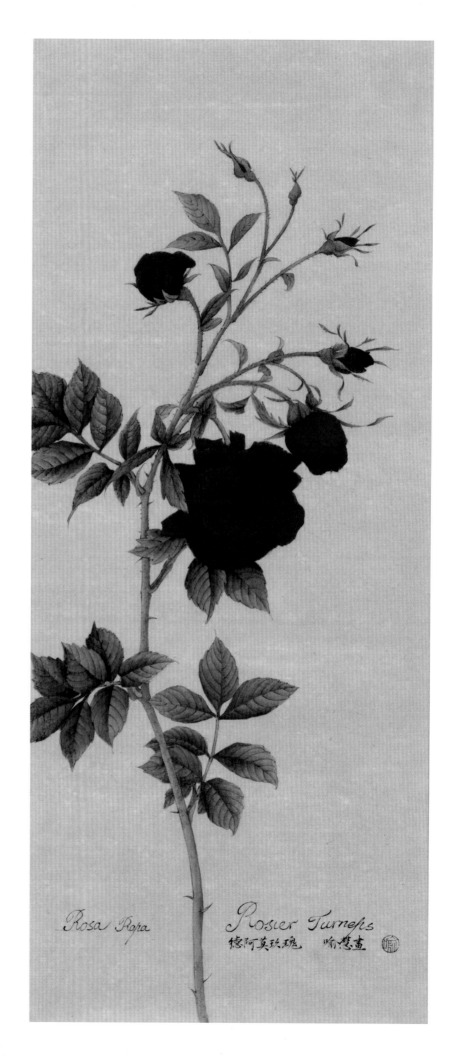

Rosa Ropa Rosier Turnefis
德阿莫玫瑰 喻慧画

04 德阿莫玫瑰

De Amo Rose

2013年
镜片
66cm×28cm

■ 款识
德阿莫玫瑰，喻慧画。
■ 钤印
喻（阳文）

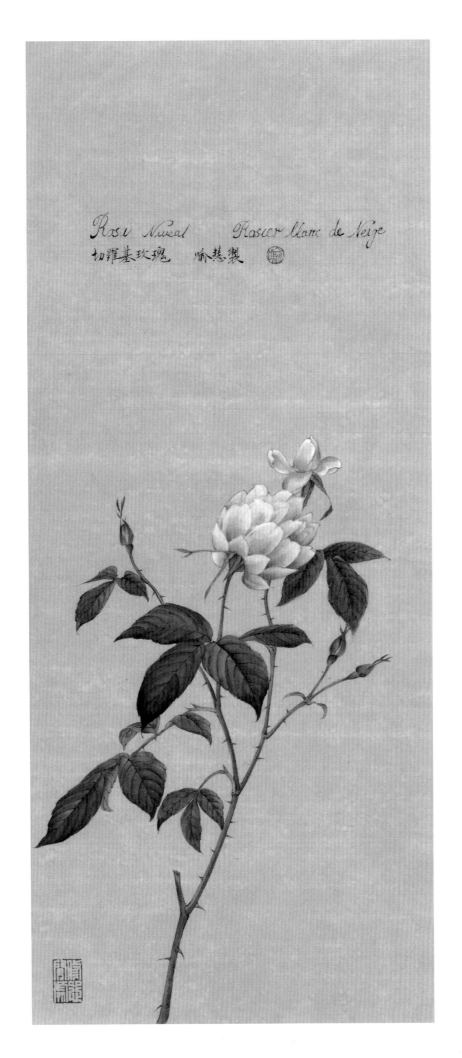

Rose Niveal *Rosier blanc de Neige*
切罗基玫瑰　喻慧製

■ 05 切罗基玫瑰
Cherokee Rose

2013年
镜片
66cm×28cm

■ 款识
切罗基玫瑰，喻慧制。
■ 钤印
喻（阳文）修心心闲处（阴文）

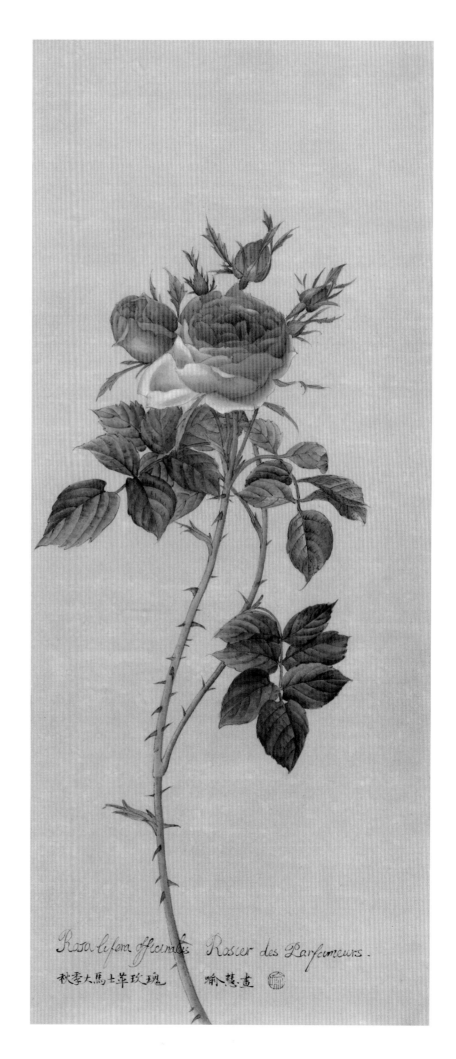

06 秋季大马士革玫瑰
Autumn Damask Rose

2013年
镜片
66cm × 28cm

■ 款识
秋季大马士革玫瑰，喻慧画。
■ 钤印
喻（阳文）

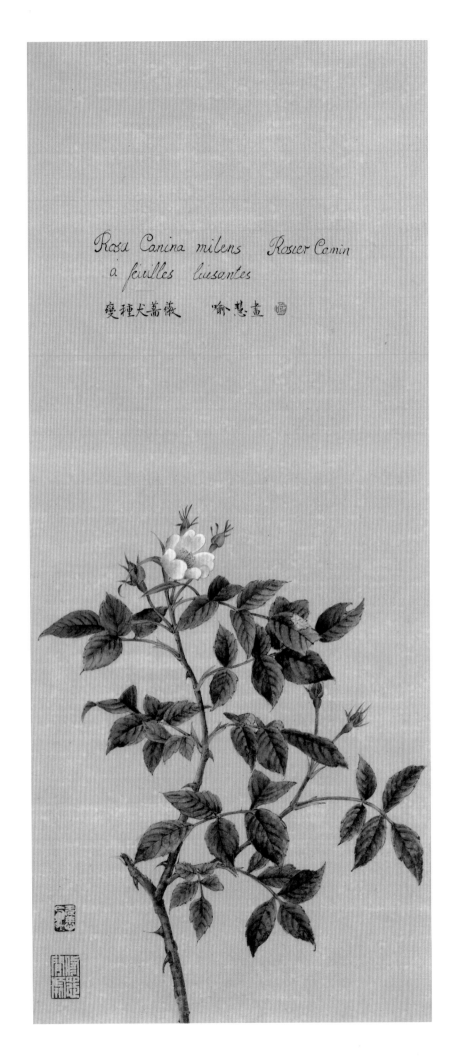

Rosa Canina milens Rosier Canin
à feuilles luisantes

變種犬薔薇 喻慧畫

■ 07 变种大蔷薇

Variants Big Rose

2013年
设色纸本
66cm×28cm

■ 款识
变种大蔷薇，喻慧画。
■ 钤印
喻（阳文）无羔鸟（阴文）修心心闲处（阴文）

Rosa Centifolia crenata

Rosier Centfeuilles a foliales crenelees

變種包心玫瑰　喻慧畫

08 变种包心玫瑰

Variant Roses Are in Bud

2013年
镜片
66cm×28cm

■ 款识
变种包心玫瑰，喻慧画。

■ 钤印
喻（阳文）修心心闲处（阴文）

图书在版编目（ＣＩＰ）数据

中国画画世界. 7，意大利、德国、法国卷 / 南京博
物院编著. —— 南京 ：江苏美术出版社，2013.10
ISBN 978-7-5344-6872-8

Ⅰ. ①中… Ⅱ. ①南… Ⅲ. ①中国画-作品集-中国-
现代 Ⅳ. ①J222. 7

中国版本图书馆CIP数据核字（2013）第246460号

出 品 人　周海歌

主　　编　徐湖平　庄天明
责任编辑　王林军
装帧设计　庄天明　张　君
责任校对　刁海裕
责任监印　吴蓉蓉
英文翻译　胡珺　张　君
英文译校　舒金佳

书　　名　中国画画世界.7，意大利、法国、德国卷
编　　著　南京博物院
出版发行　凤凰出版传媒股份有限公司
　　　　　江苏美术出版社（南京中央路165号 邮编：210009）
出版社网址　http://www.jsmscbs.cn
经　　销　凤凰出版传媒股份有限公司
印　　刷　南京凯德印刷有限公司
开　　本　889mm×1194mm　1/12
印　　张　11.5
版　　次　2013年10月第1版　2013年10月第1次印刷
标准书号　ISBN 978-7-5344-6872-8
定　　价　108.00元

营销部电话　025-68155677　68155670　营销部地址　南京市中央路165号
江苏美术出版社图书凡印装错误可向承印厂调换

春華

柯寒、

了河

丁方

礫石、

喻慧

幸道

樂、

启后

寧娜

春華　喻慧

梢寒　崇道

了川　樂

丁方　虎臣

嬌瑞　寧娜